THE PORTLAND
BEAVERS

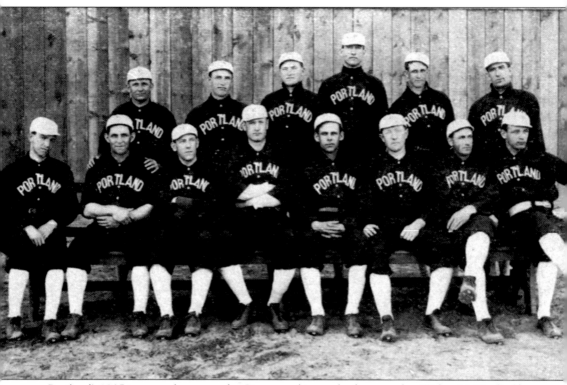

Portland's 1905 team was known as the Giants, and it was the first year that Walter McCredie (front row, fourth from left) managed the club. The Pacific Coast League played a split season that year, with Portland finishing fourth of six teams in the first half and fifth in the second half; the combined record of 94-110 was the fourth-best in the league. (Courtesy of the Ranta Collection.)

THE PORTLAND BEAVERS

Paul Andresen and Kip Carlson

ARCADIA
PUBLISHING

Published by Arcadia Publishing
Charleston, South Carolina

Printed in the United States of America

Library of Congress Catalog Card Number: Applied For.

For all general information contact Arcadia Publishing at:
Telephone 843-853-2070
Fax 843-853-0044
E-mail sales@arcadiapublishing.com
For customer service and orders:
Toll-Free 1-888-313-2665

Visit us on the Internet at www.arcadiapublishing.com

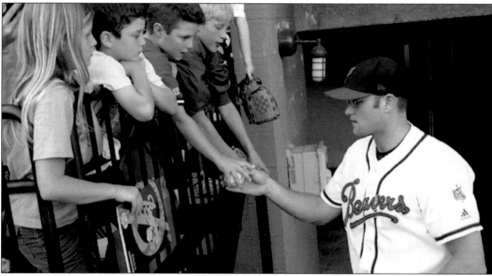

Tagg Bozied greets some young fans at PGE Park in 2003. Bozied took a slight detour on his way to the San Diego Padres organization. After wrapping up his collegiate career at San Francisco, he was taken in the third round of the 2001 draft. Rather than immediately signing with San Diego, he played the 2001 season for Sioux Falls of the independent Northern League; he set a league record with 12 homers. Bozied and the Padres finally agreed to terms before the start of the 2002 season and he spent that year working his way up the minor league ladder at Lake Elsinore and Mobile. He arrived in Portland in 2003, batting .273 with 14 homers, 25 doubles and 59 runs batted in. Bozied had been one of the nation's top collegiate players at USF, where he opted to return for his senior season and left as the Dons' career leader in hits, home runs, extra-base hits, runs batted in, runs, walks and total bases. (Courtesy of the Portland Beavers.)

CONTENTS

ACKNOWLEDGMENTS AND INTRODUCTION

As the Pacific Coast League celebrated its centennial season in 2003, the Portland Beavers were the only charter member of the league still in the PCL. To lend some perspective, it's worth noting that the Beavers' history in Portland dates back further than the relationship between team and town for 20 of the 30 Major League Baseball franchises in 2003.

Portland lost its franchise in the PCL three times—in 1918, from 1973 through 1977, and again from 1994 through 2000. When the Beavers returned in 2001, the franchise drew 439,686 fans to break an attendance record that had stood since 1947, set in the heart of the post-war baseball boom. The Beavers drew over 400,000 fans in the 2002 and 2003 seasons as well, demonstrating a renewed interest in the city's professional baseball team.

Many of those fans who have enjoyed Pacific Coast League baseball in its latest Portland reincarnation are unfamiliar with the history of their team and how it is connected with some illustrious names in the sport's history. Mickey Cochrane, Luis Tiant, Sam McDowell, Lou Piniella, Ken Williams, Stan Coveleski, Tommy John, Dave Bancroft, Harry Heilmann, Satchel Paige—even Jim Thorpe—have represented the Portland Beavers over the years.

We will not suppose to present a comprehensive history of the Portland Beavers here. Rather, our hope is to give Portland baseball fans an overview and a sampling of the history of their team in the Pacific Coast League, plus a brief look at the other professional baseball teams that have represented the city.

There are a number of people we would like to thank for sharing their knowledge, photographs, memorabilia and research skills in compiling this book: Rocky Bauer; Dick Benevento; Chuck and Brent Christiansen; Dave Eskenazi; Carroll Kirk; Art Larrance; Bill Ranta; Lucy Kopp and the staff of the Oregon Historical Society; Chris Metz and the Portland Beavers; and Gabe Schecter, Claudette Burke and the staff of the National Baseball Library in Cooperstown.

Information for this volume was gleaned from a variety of sources, including: *The Grand Minor League*, by Dick Dobbins; *Runs, Hits and an Era*, by Paul J. Zingg and Mark Medeiros; *The Pacific Coast League*, by Bill O'Neal; *The Pacific Coast League Encyclopedia*, by Carlos Bauer; *The Encyclopedia of Minor League Baseball*, edited by Lloyd Johnson and Miles Wolff; *The Ballplayers*, edited by Mike Shatzkin; *The Sports Encyclopdia: Baseball* by David S. Neft, Richard M. Cohen and Michael L. Neft; *The Ballparks of North America*, by Michael Benson; *The World War II Portland Beavers* by Donald Wells; the *Pacific Coast League 2003 Sketch and Record Book*; the series of Rollie Truitt Scrapbooks from 1948 through 1956; and Portland Beavers programs and yearbooks from 1941 through 2003.

In addition, we'd like to thank our families for their patience as we spent much of our spare time delving into the Portland Beavers' past.

Now that you have the genealogy of this book, here is the genealogy of the Beavers' past and present franchises. . . .

Portland's current franchise in the Pacific Coast League began as a charter member of the league in Los Angeles from 1903 through 1957, was located in Spokane from 1958 through 1971, and was in Albuquerque from 1972 through 2000 before moving to Portland in 2001. The Beavers of 1978 through 1993 were awarded to Portland as an expansion franchise and are now located in Salt Lake City. Portland's team of 1919 through 1972 was awarded as an expansion franchise at the end of World War I, moved to Spokane in 1973, then went to Las Vegas in 1983. The original Beavers of 1903 through 1917 went to Sacramento in 1918, moved to Hawai'i in 1961 and then relocated to Colorado Springs in 1988.

Now, some of the people and happenings from 1903 through 2003. . . .

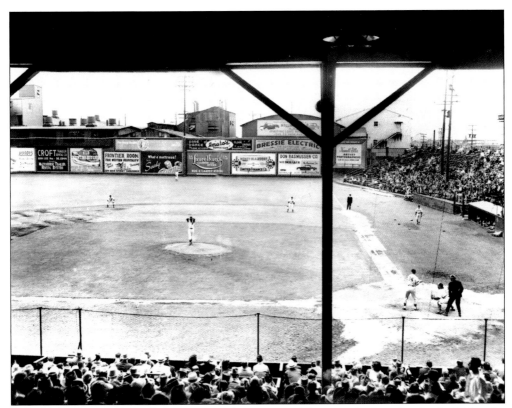

It's July 12, 1953 and the Beavers are in the process of dropping both ends of a doubleheader to the Oakland Oaks by scores of 12-9 and 10-3. Out there beyond the rightfield fence is the famous foundry; the structures on the roof gave life to a trio of common descriptions of the day—the one-barrel homer, two-barrel homer and three-barrel homer. Atop the building in deep right-centerfield are three cylindrical objects; a homer hit to the one closest the rightfield foul pole was a one-barrel homer, reaching the next one over was a two-barrel homer, and one over the edge of the centerfield bleachers was a three-barrel homer. (Oregon Historical Society neg. ORHI 54836.)

Walter McCredie managed the Beavers from 1905 through 1921 and again for part of 1934, guiding them to five Pacific Coast League pennants in one nine-year span—winning in 1906, 1910, 1911, 1913 and 1914. He managed 3,319 games in the PCL, second only to Lefty O'Doul; he is also second to O'Doul in wins and losses. McCredie came to Portland in 1904, after batting .324 in the major leagues for the 1903 Brooklyn Superbas, and became manager in 1905 when he and his uncle, Judge W.W. McCredie, bought the Beavers and established an informal working agreement with the Cleveland Indians. In 1906, Portland won its first pennant by going 115-60 to finish 19½ games ahead of second-place Seattle. McCredie was a player-manager through 1911, and he was an early proponent of breaking the color line in "organized" baseball. In January 1915, the black-owned *Chicago Defender* newspaper ran a story that outlined McCredie's attempt to sign a "half-Hawaiian, half-Chinese" outfielder named Lang Akana; his team objected strenuously to playing with a dark-skinned man and McCredie had to drop the plan. The newspaper story continued: "In announcing the release of his poi-eating prodigy, Manager McCredie took occasion to exude a few remarks relative to baseball's attitude toward Afro-American ball players. 'I don't think the color of the skin ought to be a barrier in baseball,' declared big Mac. 'They have Jim Thorpe, an Indian, in the big leagues; there are Cubans on the rosters of various clubs. Here in the Pacific Coast League we have a Mexican and a Hawaiian, and yet the laws of baseball bar Afro-Americans for organized diamonds. If I had my say the Afro-American would be welcome inside the fold." In the Beavers' heyday, McCredie was known as one of the best-dressed baseball men on the West Coast. Portland's fortunes slipped in the last half of the 1910s, though, and McCredie departed when his family sold the team after the 1921 season. That campaign saw the Beavers go 51-134, finishing 55½ games out of first place. McCredie managed Seattle for the first half of the 1922 season before becoming scout for the Detroit Tigers. In 1934, he returned to manage Portland but was seriously ill; he died on July 29 at age 57, on the eve of a game that was to have been played in his honor. (Oregon Historical Society neg. OREG 873.)

ONE

1903–1917
The McCredies and the Glory Years

When Henry Harris, president of the San Francisco club of the outlaw California League, came calling in the Pacific Northwest in December of 1902, his visit was anything but social; it would be the beginning of a chain of events that continue to this day. Harris proposed that the Portland and Seattle clubs leave the Pacific Northwest League and join his fledgling Pacific Coast League. Portland made the leap, but Seattle and Tacoma opted to stick with the old league, which had reformed as the Pacific National League. The two leagues each fielded teams in Seattle, Tacoma, Portland, San Francisco and Los Angeles in 1903 (The PCL also had a team in Sacramento), but the war was short-lived and the Pacific Coast League, which became a recognized league in 1904, won out on every front.

The Portland Browns finished a distant fifth in that inaugural 1903 season, as Los Angeles posted the only winning record in the league. The Beavers were even worse in 1904, finishing last with a 79-136 record, the most losses ever recorded in a PCL season. Pitcher Ike Butler lost 34 games for that team, a PCL record that still stood in the league's centennial season. That 1904 team also committed an astounding 669 errors, the resulting .929 fielding percentage also remained the PCL's all-time low through 2003.

After the 1904 season, Browns outfielder Walter McCredie and his uncle, Judge W.W. McCredie purchased the team, renaming it the Giants and installing Walter as the player-manager. Portland was about to embark on the most successful run in its history. Rebuilding the team in 1905, the McCredies struck for their first pennant in 1906, coincident with the team being renamed the Beavers as the result of a newspaper contest. The team was led in hitting by Mike Mitchell, who paced the league in home runs and batting average. Mitchell's six home runs still stood as the least ever by a PCL leader in that category in 2003. Mitchell might well have won the Triple Crown that year, but RBI records were not kept.

The team reverted to last place in 1907, with about the only bright spot being player-manager McCredie's league-leading 12 triples. After second-place finishes in 1908 and '09, the Beavers began a string of four pennants in five years. The great 1910 team had anemic hitting (their .218 team batting average was the lowest-ever by a PCL pennant-winner through 2003) but great pitching, led by Vean Gregg (a 32-18 record) and Gene Krapp (29-16). Gregg and Krapp were sold to the Cleveland Indians after the season, but the Beavers hardly missed a beat. Led by the fielding of Roger Peckenpaugh and hitting of Buddy Ryan (league batting and home run champion) and a staff with four 20-game winners, they repeated as PCL champs in 1911.

The Beavers dropped to fourth place in 1912, but returned to form in 1913, winning the pennant by 6½ games over Sacramento as Bill "Raw Meat" Rodgers led the league in hits and Bill James won the league strikeout crown. Again in 1914, the Beavers were the class of the

league, this time beating out Los Angeles by a narrower 3½-game cushion with Dave "Beauty" Bancroft at shortstop and pitcher Irv Higginbotham winning 31 games to top the 22 he'd won in 1913. Ty Lober was the league home run king with nine, the second-lowest total ever for a PCL leader to former Beaver Mike Mitchell's six.

In 1915, the Beavers featured future Hall of Fame pitcher Stan Coveleski but the year marked the end of a fruitful informal working agreement with Cleveland and the team plummeted to the cellar. The team improved in 1916, playing close to .500 ball and finishing fifth as pitcher Allen Sothoron paced the PCL with 30 victories. In 1917, Portland advanced one more spot to fourth place, again finishing just below .500. Grants Pass, Oregon, native Ken Williams led the PCL in home runs with 24.

Due to World War I-related travel problems, Portland dropped from the Pacific Coast League in 1918, electing instead to join the more regional Pacific Coast International League. Neither league survived the season, both halting play in July.

It was the end of an era. After the championship in 1914, the next 16 years would see the Beavers win no more pennants and finish over .500 just once.

Sylveanus Augustus Gregg—better known as Vean—from Chehalis, Washington, burst upon the scene in pennant-winning year of 1910 and turned in the greatest single season in the Beavers' pitching history. In that year, Gregg went 32-18, pitched 387 innings and had 368 strikeouts, which was still a Pacific Coast League record in 2003. He threw 12 shutouts (one source claims 14), a no-hitter and three one-hitters, one of which was 12 innings. He completed 34 of his 35 starts; as though that weren't enough, he also recorded six saves. On a notable Sunday in Sacramento, Gregg pitched both ends of a doubleheader and shut out the Solons by scores of 4-0 and 1-0. Gregg went to the major leagues in 1911 with the Cleveland Indians, with whom the Beavers had an informal working agreement. Gregg won 63 games for Cleveland from 1911 through 1913. In an eight-year career in the bigs, Gregg went 91-63 with a 2.70 earned run average. After his stay in the big leagues, Gregg came back to the PCL and pitched for Seattle from 1922 through 1924. Vean's brother Dave was a starter for the Beavers in 1912, going 5-7; he had a one-inning career with the Tribe in 1913. (Courtesy of the Eskenazi Collection.)

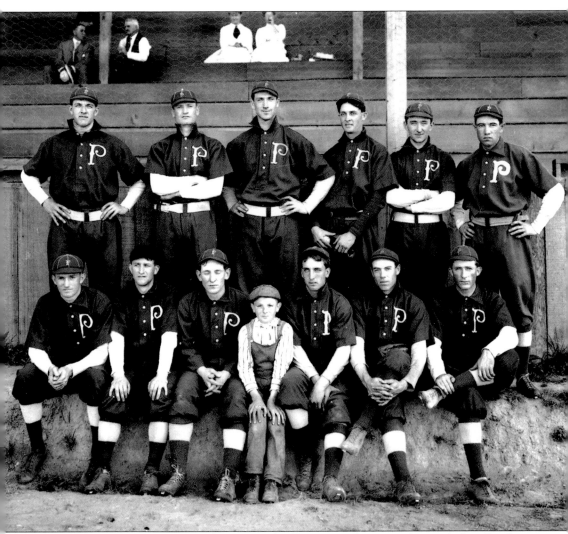

In 1906, Portland's team became known as the Beavers and it won the city's first Pacific Coast League championship. The Beavers went 115-60, winning the pennant by 19½ games. Mike Mitchell (front row, far right) was the PCL batting champion with a .351 average and led the league in homers with six; that earned the outfielder from Springfield, Ohio, a call-up to the Cincinnati Reds in 1907. He went on to play in the major leagues through the 1914 season with the Chicago Cubs, Pittsburgh Pirates and Washington Senators, batting .278 with 27 homers and 514 runs batted in, and he led the National League in triples twice. Another standout on the Beavers first championship club was third baseman Larry McLean (top row, third from left), who hit .335 with two homers that season. (Oregon Historical Society neg. OREG 4962.)

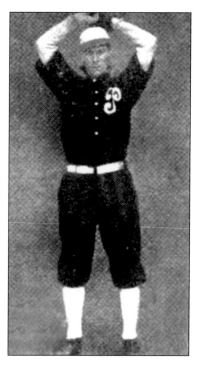

(*left*) Bill Steen was a mainstay of the Beaver mound corps, going 27-17 in 1910 and 30-15 in 1911, when he led the Pacific Coast League in wins and winning percentage. He went up to the Cleveland Indians in 1912, winning 28 games in a four-year major league career. Steen had trouble after he suffered a broken wrist in 1913 and was sold to the Detroit Tigers during the 1915 season. He ended the year back in the PCL, pitching for San Francisco. He remained there through the 1917 season, and bowed out of the league after his 1919 season with Oakland. (Courtesy of the Christiansen Collection.)

(*above, right*) Buddy Ryan was a regular outfielder for the Beavers from 1908 through 1911; he led the Pacific Coast League in hits (247), home runs (23) and batting average (.333) for the 1911 pennant-winners. He spent 1912 and '13 as an outfielder for the Cleveland Indians before returning to Portland in 1914, when he helped the Beavers to another pennant and batted .294 with three home runs. Ryan spent a long time in the PCL, with four seasons with Salt Lake City and five with Sacramento. He wasn't quite done in Portland yet, however, making a single appearance as a pinch-hitter in 1935. (Courtesy of the Eskenazi Collection.)

(*right*) Roger Peckinpaugh was one of the great shortstops developed by Walter McCredie. He had made his major league debut in 1910 as a 19-year-old with the Cleveland Indians, but was sent to Portland for seasoning and played on the pennant-winning Beavers in 1911. He hit just .258 but stole 35 bases and had great hands and a healthy arm. Peckinpaugh was back in the big leagues to stay in 1912 and had a distinguished career; in 17 seasons, he batted .259 with 48 home runs and 39 runs batted in and was the American League's Most Valuable Player in 1925. (Courtesy of the Christiansen Collection).

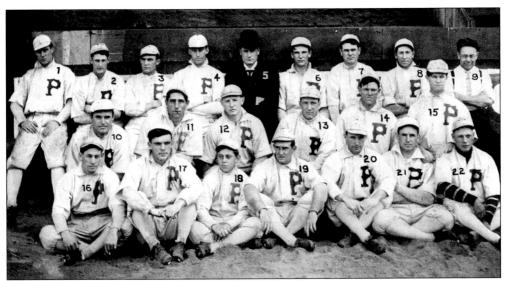

Portland's 1910 pennant-winner went 114-87, edging Oakland by 1½ games. The Beavers won the title despite batting just .222 as a team; the top mark among regulars on the club belonged to catcher Gus Fisher (second row, second from right), who hit .266 with five home runs. (Courtesy of the Larrance Collection).

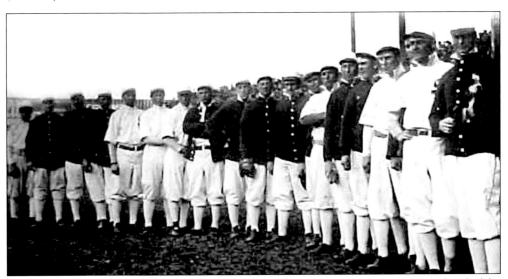

Portland made it back-to-back pennants in 1911, going 113-79 to finish two games ahead of the Vernon Tigers. It was the first year that Bill "Raw Meat" Rodgers (fifth from right) was with the ballclub; the young infielder earned his nickname by eating raw steaks and crunching raw eggs as a publicity stunt, according to *The Oregonian* sports editor L.H. Gregory. Gregory also wrote that Rodgers, who played for the Beavers from 1911 through 1914 and again in 1916 and '17, was "one of the greatest hustlers that ever played anywhere." He spent the 1915 season and the start of 1916 in the major leagues with the Cleveland Indians, Boston Red Sox and Cincinnati Reds before returning to Portland, where he finished his Beaver career with a .286 batting average; he led the PCL in hits (239) in 1913 and stolen bases (71) in 1914. Rodgers would later manage the Beavers in 1928 and '29, finishing in the second division but at one point guiding the team to 16 straight wins. (Courtesy of the Christiansen Collection.)

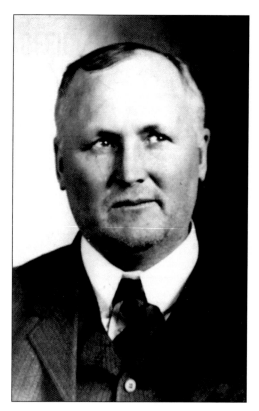

Judge William Walter McCredie owned the Beavers along with his nephew, Walter H. McCredie, from 1905 through 1921. Judge McCredie was one of the Pacific Coast League's leaders in its early years and drafted the league's schedules. After the earthquake and fire that devastated San Francisco in 1906, McCredie was one of the key figures in keeping the league going for the rest of the season as he endorsed notes guaranteeing transportation costs and went into his own pocket to help one faltering club. In 1912, McCredie was the force behind building a new grandstand at Vaughn Street; it was the 12,000-seat structure that generations of Portlanders knew as their baseball home. An obituary for McCredie noted that the ballpark was "the sensation of baseball, because it inaugurated a minor league precedent of providing individual grandstand seats, which fellow magnates called an extravagance and a dangerous innovation." The ballclub was a family operation. Besides the judge and his nephew, the judge's wife, Alice, sold tickets and handled money and Walter's cousin, Hugh, was business manager. (Oregon Historical Society neg. CN 009717.)

Harry Heilman played for the Portland Colts—essentially a Beavers farm club—in 1913, but did get six at-bats with the Beavers that year, going hitless. He was purchased by the Detroit Tigers for $1,500 and went on to rank among their all-time leaders in every major hitting category. After his playing days, Heilman was a Tigers broadcaster for 17 years. He was a lifetime .342 hitter (third-best ever among right-handers through 2003) in the major leagues, winning four batting titles. He was elected to the Hall of Fame in 1952. (Courtesy of the Christiansen Collection.)

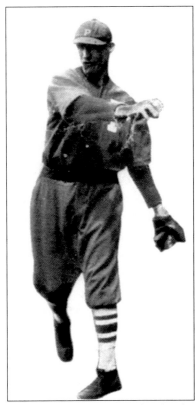

(*above, left*) There were no fancy illustrations or graphics, but transportation seemed to be the theme of Portland's scorecard in 1913. The cover also makes reference to the city's Northwestern League team, the Colts, who shared Vaughn Street with the Beavers and served as their farm team for several seasons in the 1910s. (Courtesy of the Larrance Collection.)

(*above, right*) Stan Coveleski had a brief stay with the Philadelphia Athletics in 1912, going 2-1. By 1915, he had become property of the Cleveland Indians, who had an informal working agreement with the Beavers. In Portland, he learned how to throw the spitball and had a 17-17 record with a 2.68 earned run average. In 1916, Coveleski resumed what turned out to be a long and illustrious major league career, going 215-142 with a 2.89 earned run average in 14 seasons. He won three games for the Tribe against the Brooklyn Dodgers in its 1920 World Series victory. (Courtesy of the Christiansen Collection.)

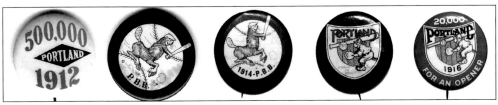

In the mid-1910s, booster buttons were popular among Portland fans. The 1914 button features a creature that combines the Beavers and their farm team, the Colts. The 1916 button encouraged the city to get 20,000 fans out to Vaughn Street for Opening Day; however, the April 18 "Big Parade" and game were rained out. The opener was played the next day in dismal conditions and 8,800 hardy fans saw the Beavers lose to Salt Lake City 13-9. (Courtesy of the Christiansen Collection, the Eskenazi Collection.)

Dave Bancroft was the Beavers' regular shortstop in 1912 and 1914, one of a string of great shortstops under Walter McCredie's stewardship. Bancroft was a picture of grace in the field, known for his quick hands and ability to handle bad hops. Through 2003, he still held the single-season major league record for chances by a shortstop, handling 984 in 1922. Bancroft played over 1,900 games in 16 big league seasons for the Philadelphia Phillies, New York Giants, Boston Braves and Brooklyn Dodgers. He was a key component on the 1915 Phillies, which won Philadelphia's first National League pennant. During his time with the Giants, Bancroft was considered the greatest shortstop that team had ever seen. Bancroft was known as "Beauty" because of his habit of yelling that word whenever things went right for his team. He was elected to the Hall of Fame in 1972. (Courtesy of the Christiansen Collection.)

Irv Higginbotham pitched for Portland from 1912 through 1915, compiling an 85-63-1 record. He went 21-14 in 1913, then paced the Pacific Coast League in wins by going 31-20 for the 1914 pennant-winning Beavers. Higginbotham pitched in the major leagues for the St. Louis Cardinals and Chicago Cubs in 1906, 1908 and 1909, winning 10 games as an occasional starter. (Courtesy of the Christiansen Collection).

There's a reason they call it "winning the pennant." Portland's prize for placing first in the Pacific Coast League in the early part of the century were silk pennants roughly eight feet high by three feet wide at the top; the 1911 banner was red and the 1914 banner blue. (Courtesy of the Christiansen Collection.)

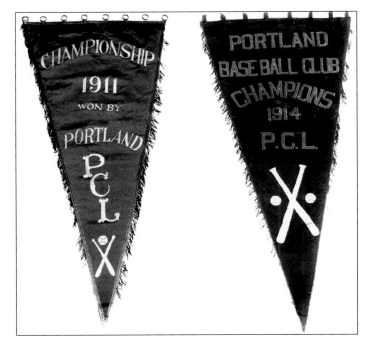

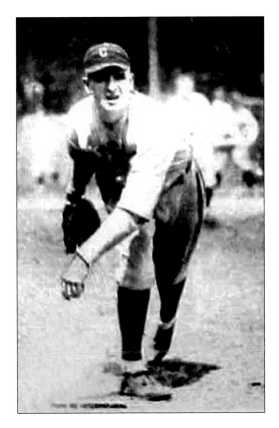

Walter "Duster" Mails made his Pacific Coast League debut with the 1917 Beavers, picking up a 3-2 record as a reliever. Mails won only 32 games over seven years in the major leagues, but seven of those victories came in September, 1920, when he almost single-handedly pitched the Cleveland Indians to the American League pennant, shutting out the Chicago White Sox for the pennant-clincher. He then threw 15 innings without allowing an earned run in two appearances in that year's World Series as the Tribe beat the Brooklyn Dodgers. Mails, plagued with a perpetual sore arm, was a PCL mainstay, winning 173 games from 1917 through 1936. During that time, Mails made a return visit to Portland, winning 11 games in 1930 and 13 in 1931. (Courtesy of the Christiansen Collection.)

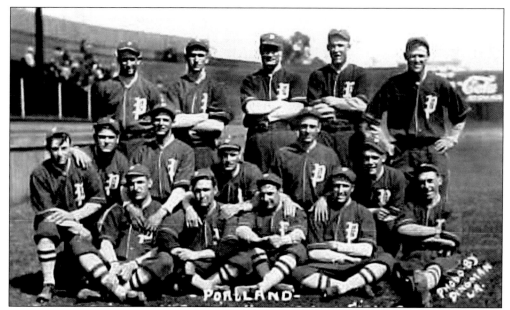

After finishing 26 games out of first place the year before, the 1913 Beavers brought Portland another Pacific Coast League pennant; their record of 109-86 left them seven games ahead of Sacramento. Bill James (front row, far left), who compiled a 24-16-2 record, was the PCL's strikeout leader with 215. Bill Rodgers (front row, second from left) led the league with 239 hits and batted .305. (Courtesy of the Christiansen Collection.)

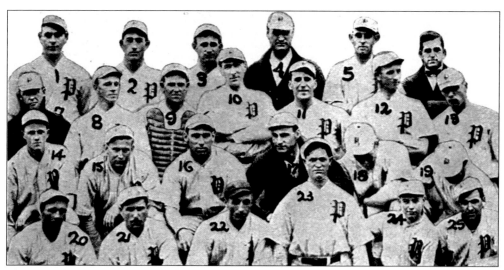

The 1914 Beavers represented what was referred to by L.H. Gregory of *The Oregonian* as "the last of the charmed years." Winning Portland's fifth Pacific Coast League pennant in nine years, the Beavers went 113-84, finishing 3½ games in front of Los Angeles. Outfielder Ty Lober (third row, far right), reputed to have one of the strongest arms in the PCL, was also the league-leader with his nine home runs; Irv Higginbotham (back row, second from left) topped the league in wins with a 31-20 record. (Courtesy of the Larrance Collection.)

Two

1919–1930
The Not-So-Roaring Twenties

In 1919, Portland rejoined the Pacific Coast League after its World War I-related absence of one year. Seattle, which had been gone from the league since 1907, also rejoined to give the league eight teams for the first time; that format which would continue until the league expanded to 10 teams in 1963. The two Pacific Northwest teams fared poorly in 1919, with Portland finishing seventh and Seattle eighth. While Seattle improved dramatically in 1920, Portland slipped into the cellar, a performance the Beavers would repeat in 1921. The "Roaring Twenties" would prove to be anything but roaring for the Beavers, as they produced second-division finishes in 10 of the 12 years from 1919-30.

After the 1921 season, the club was sold to Walter Klepper, former president of the Seattle team. Klepper traded Herm Pilette and Sylvester Johnson to Detroit for an almost entirely new lineup. It helped a little, as the team rose to seventh place in 1922, but Klepper was in hot water. He was suspended by baseball commissioner Kennesaw Mountain Landis for perceived shenanigans with players from Seattle who ended up on the Portland team. The feisty Klepper went to court and had the decision overturned, supposedly the only time that Landis ever had a ruling reversed.

In 1923, the Beavers posted their best mark of the decade with a third-place finish and a 107-89 record. Yes, that's almost a 200-game season; because of favorable weather, the PCL routinely played schedules of 180 to 220 games until well into the 1950s.

The 1924 season saw the arrival of Mickey Cochrane, who would go on to a Hall of Fame career with the Philadelphia Athletics. Not so coincidentally, the team was purchased after the 1924 season by Athletics owners John and Tom Shibe, who made Athletics manager Connie Mack's son Roy the vice president and business manager. The Shibes also purchased the Vaughn Street ballpark, which was still owned by the two trolley companies who had built it in 1901. Cochrane was a fine player, but not enough to help the Beavers as they slid back to seventh place.

In 1925, the team brought in Duffy Lewis, a member of the famed Boston Red Sox outfield in the 1910s, as player-manager. The future Hall of Famer had won the PCL batting championship with Salt Lake City the previous year, but that didn't impress the locals and Lewis left before the year was out. Truck Hannah took over the club for the remainder of the year, bringing the team home in fifth place.

Elmer Smith, of 1920 World Series Fame, joined the team for 1926 and '27, but despite his leading the Pacific Coast League in home runs in 1926 and leading all of minor league baseball in homers in 1927, the Beavers finished fourth and fifth those two years. After the 1927 season, the Beavers sold shortstop Bill Cissell, who had hit .323, to the Chicago White Sox for $123,000, which helped the club's financial situation considerably.

In 1928, Ike Boone, in a prelude to his monster Triple Crown year for Mission (.407 average, 55 homers, 218 RBIs) led the team in hitting with a .354 average. In fact, the Beavers had eight players hit over .300 that year, but they fell to seventh place with a 79-112 record. Every pitcher on the team, save Ed Tomlin at 9-8, had a losing record. Even Larry French, who would pitch throughout the 1930s in the major leagues, was only 11-17.

After a miserable 33-36 first half in 1929, the Beavers sported a 57-46 mark for the second half of the split-season format. Pitcher Roy Mahaffey and first baseman Jim Keesey were named to the PCL all star team. Portland showed off the "reversible battery" of Ed Tomlin and Junk Walters, who on at least one occasion were the pitcher and catcher in the first game of a doubleheader, then exchanged positions for the second game. Once more, the Beavers experimented with their name and were known as both the Ducks and sometimes the Rosebuds, even featuring a picture of a duck on the uniforms. The names didn't stick; by 1930, the Beaver name was back in force although the team would occasionally be referred to as the Ducks as late as 1940.

The highlight of the 1930 season was probably Portland second baseman William Rhiel's unassisted triple play, the last recorded in the PCL through the 2003 season. Portland's pitching staff had major league veteran Carl Mays and longtime PCL stalwart Duster Mails, but even the .347 hitting of future major league star Doc Cramer couldn't overcome a sky-high staff ERA. The Beavers closed out what had been an era of futility with an appropriate last-place finish in 1930, their 81-117 record leaving them 37 games off the pace. However, better things were ahead.

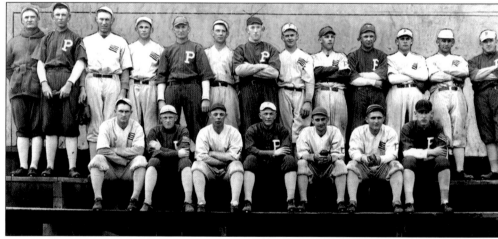

The 1919 Beavers returned Portland to the Pacific Coast League after a one-year absence, going 78-96 to finish seventh in the PCL's first season as an eight-team league. The club included first baseman Lu Blue (front row, second from left), who went on to bat .278 for the Detroit Tigers, St. Louis Browns, Chicago White Sox and Brooklyn Dodgers from 1921 through 1933; and catcher Del Baker (front row, third from left), who was from nearby Sherwood, Oregon and went on to play three years for the Detroit Tigers. In 1918, Portland had left the PCL due to travel difficulties caused by World War I. Seattle had not yet joined the league and the Beavers' role as the sole Pacific Northwest entry was a hurdle to coming up with a workable schedule when space on trains was at a premium. Portland did have a team in the 1918 Pacific Coast International League, which suspended operations on July 7; the PCL closed down its season a week later. (Oregon Historical Society neg. ORHI 58240.)

King Gustav of Sweden told Jim Thorpe, "Sir, you are the greatest athlete in the world." That was in 1912, when Thorpe won both the pentathlon and decathlon at the Stockholm Olympics. A decade later at age 35, Thorpe played for the 1922 Beavers, batting .308 with one homer, two triples, three doubles, 14 runs batted in and five stolen bases in 35 games. Owner Bill Klepper, in his first year on the job, brought in Thorpe at the then-unheard-of minor league salary of $1,000 per month. Thorpe is shown at the Beavers' home opener with actress

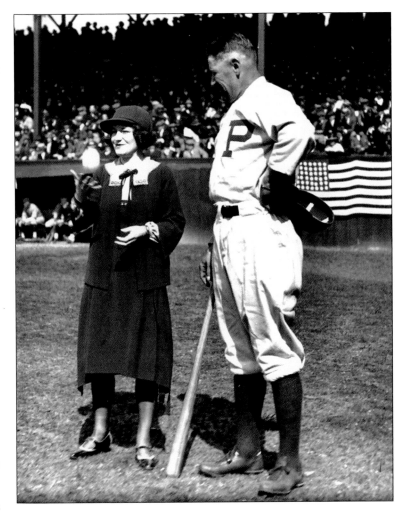

Viola Dana, who was on hand as the batter for the ceremonial first pitch. The Opening Day crowd of 20,167 at Vaughn Street was proclaimed to be the largest ever to see a baseball game on the West Coast up to that time.

During the Beavers' spring training camp, The Oregonian's L.H. Gregory noted that at one midday meal, "Jim Thorpe declined to drink any of the milk or to eat the sandwiches or pie. Big Jim's favorite food is hardtack. He says it is great stuff to train on in the football season and that it ought to be just as good for baseball. If hardtack can make the other players as tough as Jim, the duke will order a carload of the stuff, but there seems to be a difference of opinion as to its efficacy." Thorpe's first brush with minor league baseball had cost him his Olympic gold medals; he had to return them when it was learned he'd played for $60 a month in a low-level league in 1909. That violated the strict amateur code that governed the Olympics at the time. Once he was openly professional, Thorpe set about showing his athletic diversity. He put together a career with the Canton Bulldogs and New York Giants that earned him a place in the Pro Football Hall of Fame; he also spent six seasons (1913 through 1915 and 1917 through 1919) in the major leagues with the New York Giants, Cincinnati Reds and Boston Braves. For his career, he batted .252 with seven homers; that included a .327 batting average in 1919 as he saw limited action with the Giants and Braves. (Courtesy of the Carlson Collection.)

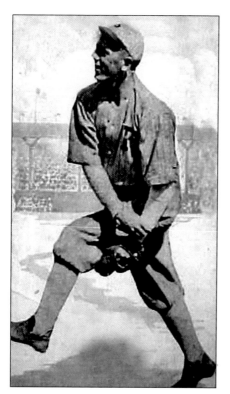

Portland native Syl Johnson pitched for the Beavers in 1920 and '21, posting a 13-30 record for a pair of last-place teams. He went to the major leagues in 1923 and began a 19-year journeyman career with the Detroit Tigers, St. Louis Cardinals, Cincinnati Reds and Philadelphia Phillies. He pitched in the World Series in 1928, 1929, and 1931 for St Louis. When his big league career ended in 1940, he returned to the Pacific Coast League, pitching for Seattle during World War II. Johnson was considered injury prone and seemed to attract line drives; at various times he broke his cheekbone, ribs, big toe, and three fingers on his pitching hand. (Courtesy of the Christiansen Collection.)

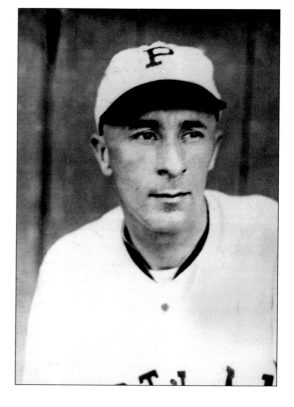

Art Stokes spent part of the 1925 season with Portland and part with the Philadelphia Athletics. Stokes, a right-hander from Emmitsburg, Maryland, was 3-3 with a 4.59 earned run average for the Beavers and 1-1 with a 4.07 ERA for the A's. The Athletics owners, Tom and John Shibe, had purchased the Beavers prior to the start of the season for $275,000; the main reason was to acquire the rights to future Hall of Fame catcher Mickey Cochrane. (Oregon Historical Society neg. CN 009615.)

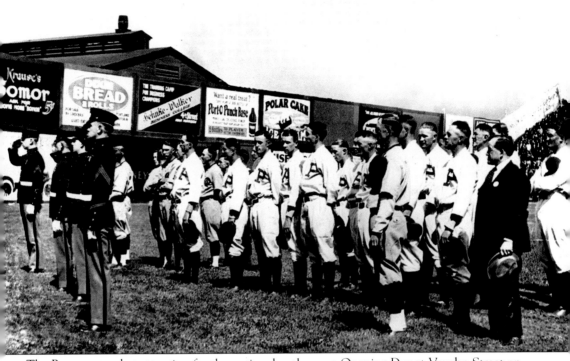

The Beavers stand at attention for the national anthem on Opening Day at Vaughn Street on April 18, 1922. For a team coming off one of the worst seasons in professional baseball history—Portland was 51-134 and finished 55¹/₂ games out of first place in 1921—the Beavers got one heck of a welcome. The week before the game, Mayor George Baker proclaimed a "half-holiday" from 12 noon until 6 p.m. The city's Hart, Schafner & Marx outlet not only announced that it would be closed at that time, but also bought a ticket for each of its employees. Standard Oil and the Union Pacific Railway also closed for the afternoon. There would be a parade to mark the occasion, led by the Beavers and the Oakland Oaks in automobiles. The crowd wouldn't be limited to folks from the metropolitan area; L.H. Gregory reported in *The Oregonian* that fans from McMinnville, Astoria and even had Marshfield (now Coos Bay) would make the trip. Came Opening Day, and 20,107 fans wedged their way into Vaughn Street; that did not include passes, and the club's attendance announcement also said that up to 1,500 more people climbed the fences or pushed their way into the ballpark. "Say it no more in tones of apology and doubt that Portland will come back as a baseball town," Gregory wrote. "Rather, tell it to the world that Portland has come back . . . a turnout of 20,000 men and women and children, the greatest crowd by far that ever saw a ballgame in this city or in any city on the Pacific coast, thronged grandstand, bleachers and playing field to welcome home the Portland Beavers in their opening game against Oakland." Alas, Oakland scored three times in the ninth inning to hand the Beavers a 4-1 loss. One of those Beavers assembled for pregame ceremonies was Jim Poole, the Beavers' regular first baseman from 1921 through 1924. In 1924, he led the Pacific Coast League with 38 home runs while hitting .353 and driving in 159 runs; for Portland, he never had fewer than 20 homers or 100 RBIs in a season. Poole did reach the major leagues with the Philadelphia Athletics but eventually became the quintessential career minor leaguer, playing for 30 different teams. Poole played until 1946—when he was 51 years old—then continued as a minor league manager until 1960. (Courtesy of the Carlson Collection.)

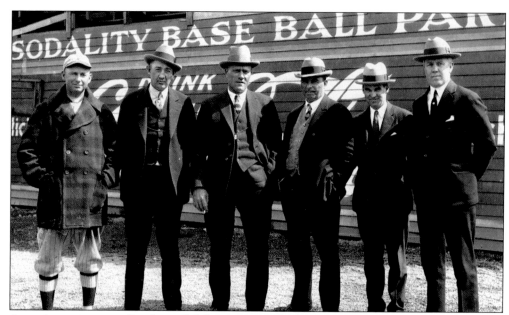

At spring training in San Jose, California, in 1925, the Beaver brain trust at Sodality Park includes manager Duffy Lewis (far left), owner Tom Turner (far right), and next to him, business manager Roy Mack, son of the famous Connie Mack. In addition to managing, Lewis played the outfield and first base, hitting .294 with 15 home runs in 130 games. (Courtesy of the Eskenazi Collection.)

Not many players can claim to be such a hot prospect that they cause an entire team to change hands. One such player was Hall of Famer Mickey Cochrane, the Beavers' catcher in 1924, and he was worth every penny of the deal. Cochrane was a professional baseball rarity, a college man, graduating from Boston University in 1923 and beginning his minor league career in Dover, Delaware. The Beavers coveted Cochrane, as did the Philadelphia Athletics. Portland purchased Cochrane, and the Beavers were in turn purchased by Tom and John Shibe, who had been majority owners of the Athletics since the passing of their father, Benjamin Shibe, in 1922. In Cochrane's season in Portland, he batted .333 with seven home runs and 56 runs batted in. The Athletics brought him up and Cochrane immediately took over Philadelphia's catching duties. He eventually became the spark of the great Athletics teams of 1929 through 1931, making three consecutive World Series appearances, winning in 1929 and 1930 and barely losing in 1931. Cochrane was named the American League's Most Valuable Player in 1928 while playing for Philadelphia and again in 1934 while playing for the Detroit Tigers. He managed the Detroit Tigers from 1934 through 1938, winning the World Series in 1934. Cochrane was elected to the Hall of Fame in 1947. (Courtesy of the Christiansen Collection.)

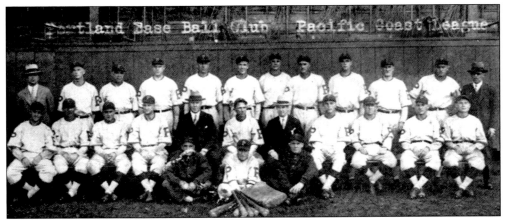

Not only was 1927 Rocky Benevento's first season as the groundskeeper at Vaughn Street, but it marked the first time Portland had the same manager for back-to-back full seasons since Walter McCredie left the club. That was Ernie Johnson (second row, sixth from left), a player-manager who had a career in the major leagues from 1912 through 1925 with the Chicago White Sox, St. Louis Browns and New York Yankees; he'd also played for the Federal League team in St. Louis. In Chicago, Johnson had been the man to take over at shortstop when "Black Sox" star Swede Risberg was banned for life. In New York, he'd been a teammate of Babe Ruth. Later, Johnson's son Don would play the 1932 season at Oregon State, then sign that summer with Seattle, where his father was managing. After a lengthy Pacific Coast League career, Don Johnson was the starting second baseman on the Chicago Cubs' 1945 pennant-winners. Ernie Johnson managed to keep the Beavers on an even keel—the club finished in fourth place with a 100-101 record in 1926, then was fifth at 95-95 in 1927. Another notable figure on the team was Oregon alumnus Carson "Skeeter" Bigbee (second row, third from right). Bigbee, who was born just east of Lebanon, Oregon, in the hamlet of Waterloo, had been an outfielder for the Pittsburgh Pirates from 1916 through 1926, batting .287 with 17 home runs and 324 runs batted in. He spent part of 1927 and 1928 with Portland, hitting .259 over those two seasons. (Courtesy of the Larrance Collection.)

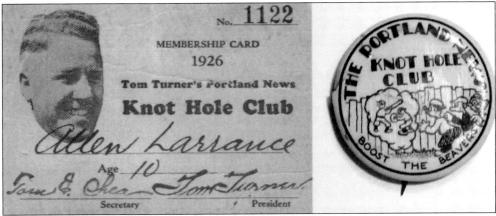

In the late 1920s, a member of the Beavers' Knothole Gang might be identified by their membership card or button. The club, named for team president Tom Turner, was sponsored by the *Portland News*. Membership gave cardholders admission to a special Knothole Club section on Saturdays during the school term and on Wednesdays and Fridays during the summer. (Courtesy of the Christiansen Collection, the Larrance Collection.)

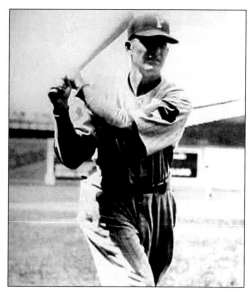
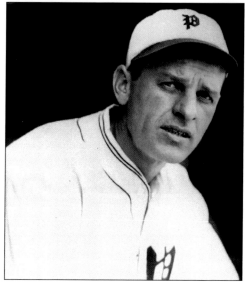

(*above, left*) Elmer Smith came to the Beavers in 1926 at age 34 after a 10-year major league career, and he led the Pacific Coast League with 46 home runs that year. He was again the PCL's home run champ with 40 in 1927 and he batted a combined .352 over those two seasons. He started 1928 with the Beavers but went to Hollywood, and he continued to play in the minors until 1932. Smith is most remembered for hitting the first grand slam in World Series history, in Game Five of the 1920 Fall Classic for the Cleveland Indians. (*Courtesy of the Christiansen Collection.*)

(*above, right*) Art Jahn split the 1929 season between Portland and San Francisco, batting .304 with three homers, three triples and a whopping 44 doubles for the season; he drove in 92 runs and stole five bases. Jahn had played briefly for the Chicago Cubs in 1925. He spent 1926 and '27 with Los Angeles in the Pacific Coast League, batting over .335 each season. (Oregon Historical Society neg. CN 012032.)

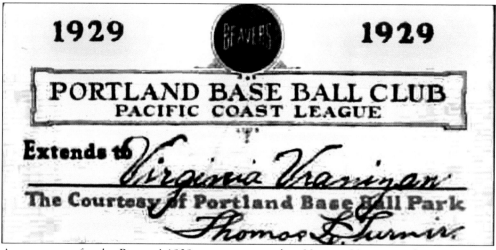

A season pass for the Beavers' 1929 campaign issued to Virginia Vranizan, who was likely a relative of George Vranizan, the team's secretary. Portland finished last in the season's first half, then managed a third-place finish in the second half. For the year, the Beavers had a 90-112 record, sixth-best in the eight-team league. (*Courtesy of the Christiansen Collection.*)

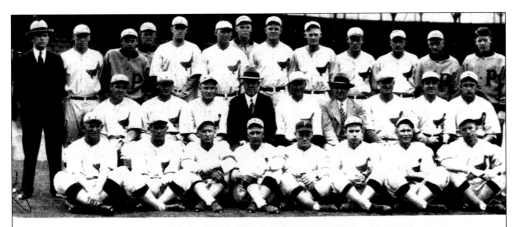

THE PORTLAND DUCKS OF 1929

Back Row — Left to right: Geo. Vranizan (Sec.), David Harris, Chas. Bates, Bob Trembly, Fred Ortman, Jim Keesey, Hank McDonald, Ed Tomlin, George Snide
Roy Mahaffey, Roy Chesterfield, John Beck, Jim Turner, Trainer.

Middle Row — Left to right: Mack Hillis, Bob Johnson, Francis Sigafoos, Thomas L. Turner (Pres.), Bill Rodgers (Mgr.), Roy Mack (Bus. Mgr.), Curtis Fullerto
Joe Cascarella, Joe Bowman.

Front Row — Left to right: "Junk" Walters, Larry Woodall, "Buster" Chatham, "Tony" De Rego, "Bud" Simkins, (Mascot), Ray O'Dell, Gale Stale
Bill Posedel.

In 1929, Portland's management tried switching the team's nickname to the Ducks; note the duck emblem on the team's jerseys. It never caught on with the press or public, though, and the team finished a cumulative sixth place during a split season with a 90-112 record. The squad did include a pair of Pacific Coast League all-stars, however—first baseman Jim Keesey and pitcher Roy Mahaffey. Keesey (back row, sixth from left), batted .349 with 12 home runs, 124 runs batted in and 17 stolen bases; Mahaffey (back row, fourth from right) was 21-25 with a 4.01 earned run average but that included pitching in 56 games and a whopping 370 innings. Portland would be sporadically referred to as the Ducks until as late as 1940. (Courtesy of the Ranta Collection.)

Carl Mays, who threw the notorious pitch that beaned and killed Ray Chapman of the Cleveland Indians in 1920, played in Portland at each end of his career. In 1913 he played for the Portland Colts, effectively a Beaver farm team, along with future Hall of Famer Harry Heilman. Two years later, Mays was in the major leagues, where he would win 215 games for the Boston Red Sox, Cincinnati Reds, New York Giants and New York Yankees. In 1930, he began the year with Toledo before going to Portland, where he started 18 games and had a 5-9 record. Mays was a fine hitter by pitchers' standards, with a lifetime .268 major league batting average. (Courtesy of the Christiansen Collection.)

Ken Williams' years in Portland provided neat bookends to a distinguished major league career for the native of Grants Pass, Oregon. The left handed-hitting outfielder spent time with the Cincinnati Reds in 1915 and '16 before joining the Beavers for the 1916 and '17 seasons. He spent most of 1918 in the military, but managed to play a few games for the St. Louis Browns and he stayed with them through the 1927 season. He then spent 1928 and '29 with the Boston Red Sox. With his major league career over, Williams returned to his home state to play for the Beavers in 1930 and '31. Williams had his best year for the Browns in 1922, leading the American League with 22 homers, 155 runs batted in and 367 total bases while batting .332. He also had 11 triples and stole 35 bases, making him the first player to ever have a season with at least 30 homers, 30 stolen bases and a .300 batting average. In his major league career, Williams batted .319 with 196 homers and 913 RBIs. Williams was one of six brothers whose mother cooked at a logging camp and later ran a restaurant serving train crews passing through Grants Pass. In his first stay with the Beavers, Williams led the Pacific Coast League with 24 homers in 1917; he also batted .313 that season and stole 61 bases. Back at Vaughn Street in 1930, Williams hit .350 with 14 homers and 110 RBIs and still stole 23 bases at age 40. (Courtesy of the Eskenazi Collection.)

THREE

1931–1945
More Pennants and World War II

In 1931, the Beavers changed hands once again, as Tom Turner bought the team from the Shibe brothers. Things immediately began looking up, as the team won 100 games and finished a solid third. Ed Coleman led the Pacific Coast League in hits (275) and runs batted in (183), and John Monroe paced it in runs (141). Both made the all-star team along with utility infielder Billy Riehl.

The 1932 edition of the Beavers brought home Portland's first pennant since 1914. This club was the opposite of the great teams of the 1910s, with relatively weak pitching but exceptional hitting, featuring the strong bat of future major league star Pinky Higgins at third base and outfielder Lou Finney, who led the league with 268 hits. Finney and Higgins were both league all-stars.

The club slipped to second place in 1933, then tumbled to the basement in 1934 as the club went through three managers, with even owner Tom Turner trying his hand. Attendance tumbled as well, setting an all-time franchise low of 50,731, fully one-quarter of whom showed up on Opening Day. Walter McCredie was brought back to manage but he was not a well man, and he died on the eve of planned ceremonies to honor him. Again, the team changed hands, Turner selling out to E.J. Schefter. The team rose to fourth place in 1935, squeaking in one game over .500; more importantly, attendance rebounded to 228,000 for the year. Despite these positive signs, few gave the Beavers much of a chance in 1936.

Portland began 1936 with former Philadelphia Athletics star Max Bishop at the helm and, at management's insistence, playing second base. But Bishop wanted to play the promising Pete Coscarart there, and Bishop was eventually fired when he wouldn't cooperate and put himself in the lineup. Bill Sweeney, the team's first baseman, stepped in and took the team to the regular season title on the last day. Portland then beat Seattle four games to none in the first round of the playoffs and Oakland four games to one in the championship series. Pitcher Ad Liska made his Portland debut, winning the first 15 of his eventual 198 career victories for the Beavers.

In 1937, Portland dropped to fourth place but still made it into the playoffs, defeating San Francisco in the first round before losing to eventual champion San Diego, which had a skinny kid named Ted Williams in its outfield. The 1938 outfit had three strong pitchers in Whitey Hilcher, Bill Thomas and Ad Liska, but little hitting and no power. The team dropped to sixth place, presaging four straight last-place finishes from 1939 through 1942.

In 1939, Thomas and Liska each won 20 games and the Beavers had eight players hit over .300, but no other pitchers entered double-digits in wins, and the team settled in for an extended stay in the PCL cellar.

The 1940 team produced the worst Beaver record—56-122—since the dreadful 1921 outfit, finishing 56 games behind league champion Seattle, the furthest Portland would ever finish

out of first through the team's centennial season. The Beavers were so far behind the rest of the league that they were even 25 games behind seventh-place San Francisco. Not one pitcher on the team could produce a winning record and attendance dropped below 100,000 for only the third time in team history.

The team again finished last in both 1941 and '42, but found a "new" star in minor league veteran Ted Norbert. In 1942, Norbert ran away with the batting title with a .378 average, precisely 100 points higher than he hit for the Beavers in 1941. He also paced the league with 28 home runs.

In 1943, William Klepper re-entered the picture; along with George Norgan, he again purchased the team and the Beavers responded with their first winning record since 1937. With management now dubbing them the "Lucky Beavers," Portland made the PCL playoffs and lost to San Francisco in the first round. The pitching was much-improved, led by reliable Ad Liska's 17-11 record. World War II was savaging the ranks of Major League Baseball and the minors as well, but Portland—somewhat like the St Louis Browns in the American League—managed to become "less bad" than the rest of the circuit.

The Beavers continued to move up, finishing second in 1944, but they again lost in the first round of the playoffs, this time to Los Angeles. Pitcher Mario Pieretti was the league's winningest pitcher, posting 26 victories. The hitting was not spectacular but solid from top to bottom, with seven players each contributing more than 40 RBIs.

Finally, in 1945, another pennant came to Portland, led by player-manager Marv Owen. Five regulars hit over .300, and each drove in at least 60 runs. Liska, Burt Pulford and Roy Helser each won exactly 20 games and the Beavers took the pennant by 8¹/₂ games. Again the team was luckless in the playoffs, losing to San Francisco in the first round. The Beavers had survived the war in good shape, and were ready to take part in the boom that minor league baseball was about to experience.

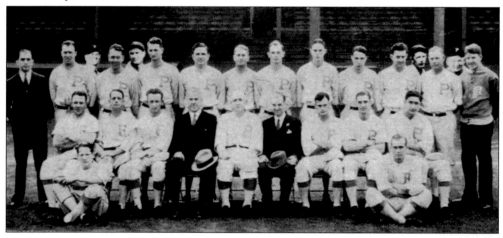

The Beavers of 1931 returned a sense of baseball decency to Portland; finishing with the third-best overall record at 100-87 over a split season gave the club its best Pacific Coast League standing since 1923. One key figure in the improvement was outfielder Ed Coleman (back row, sixth from left). A native of Canby, Oregon, Coleman went on to star at Oregon State and was the brother of the school's longtime coach, Ralph Coleman. In 1931, Coleman led the PCL in hits (275) and runs batted in (183) while batting .358 with 37 home runs and being named to the all-star team. The next season, he started a five-year career in the major leagues with the Philadelphia Athletics and St. Louis Browns. Also named to the 1931 PCL all-star team were second baseman John Monroe (middle row, second from left), who hit .362 during a season in which he came over from Mission at midseason, and utility player Billy Rhiel (middle row, far left), who hit .346 with a league-leading 53 doubles. (Courtesy of the Ranta Collection.)

Walter McCredie (center) had seen many great days in Portland but they were more than a decade in the past when he visited the Beavers' spring training in 1931. At the time, McCredie was scouting for the Detroit Tigers. Tom Turner, who had recently taken over the Portland team, is on the left and Roy Mack, the Beavers' business manager and son of legendary Philadelphia Athletics owner and manager Connie Mack, is on the right. Three years later, Turner hired McCredie to manage the 1934 season; McCredie died early in the season. (Courtesy of the Ranta Collection.)

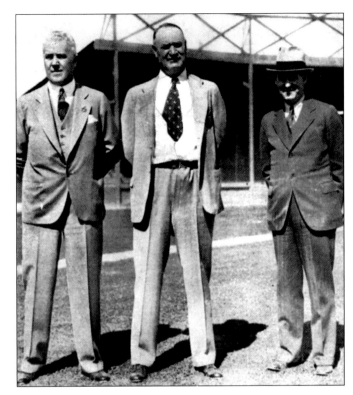

Brothers Steve (left), Pete (right) and Joe Coscarart hailed from Escondido, California, and were Pacific Coast League mainstays in the 1930s and 1940s. All three played for the Beavers at one time or another. Steve, an infielder and outfielder, played in Portland from 1934 through 1938, batting .278 with 14 home runs and 170 runs batted in. Pete, a second baseman, played from 1934 through 1937, hitting .243 with six homers and 119 RBIs. Joe, an infielder, played in 1941 and hit .180 with seven RBIs. Steve never reached the major leagues but Joe played for the Boston Braves in 1935 and '36, batting .241 with three homers and 73 RBIs, and Pete played for the Brooklyn Dodgers from 1938 through 1941 and the Pittsburgh Pirates from 1942 through 1946, batting .243 with 28 homers and 269 RBIs. Pete was on the Dodgers' 1941 pennant-winners; in a World Series loss to the New York Yankees, he was 0-for-7 in three games. (Courtesy of the Ranta Collection.)

It's Opening Day of the 1932 Pacific Coast League season, and Portland is visiting Los Angeles at Wrigley Field. The managers exchanging a "good luck" handshake are the Angels' Jackie Lelivelt, left, and the Beavers' Spencer Abbott. Abbott would guide the Beavers to that season's PCL pennant with a 111-78 record, finishing five games ahead of Hollywood. Abbott managed Portland from 1931 through 1933. In 1931, Portland finished a cumulative third place during a split season with a 100-87 record. In 1933, the Beavers just missed repeating as champs when they finished second at 105-77, 6½ games behind Lelivelt's Angels. (Oregon Historical Society neg. ORHI 085310.)

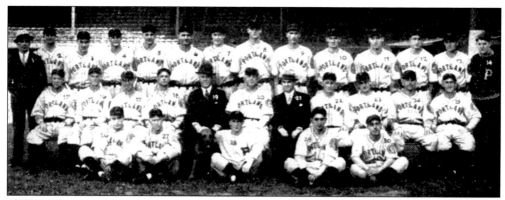

Portland finally returned to the winner's circle in 1932, capturing the Pacific Coast League pennant for the first time since the end of the McCredie family's glory years in 1914. Outfielder Lou Finney (back row, fifth from left) was named to the PCL all-star team after leading the league with 268 hits and batting .351. Outfielder-second baseman Bob Johnson (back row, third from left) led the league with a .572 slugging percentage as he hit .330 with 29 homers, while third baseman Pinky Higgins (back row, fifth from right) hit .326 with 33 homers. (Courtsey of the Larrance Collection.)

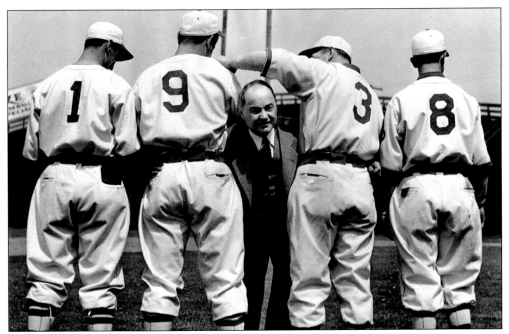

E.J. Schefter, shown here looking forward to the 1938 season with four of the Beavers, was a Portland druggist and manufacturer who bought the team from Tom Turner in 1935. Schefter served as the team's president and general manager. His son Rollie, a semipro catcher who had just graduated from Notre Dame, was the team's business manager. In 1936, Portland won its second pennant in five years when the Schefters fired manager Max Bishop, a former Philadelphia Athletics star, early in the season and replaced him with Bill Sweeney. In 1942, with World War II underway, Schefter sold the team to a group headed by William Klepper. (Courtesy of the Eskenazi Collection.)

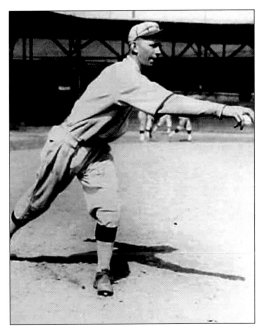

When he wasn't serving two stints in the U.S. Navy—which earned him the nickname "Barnacle Bill"—Bill Posedel pitched for Portland from 1929 through 1931 and again from 1935 through 1937. During that time, he had a 61-37 record, including 20-10 with a 2.82 earned run average for Portland's 1936 pennant-winner, then went 21-12 with a 3.09 ERA in 1937. He went up to the Brooklyn Dodgers, then pitched for the Boston Braves through 1941 until returning to the U.S. Navy. Posedel originally drew notice from scouts in the 1920s, pitching the USS Saratoga team to the Pacific Fleet Championship. He returned to the Braves in 1946 but was ineffective, wrapping up his major league career with a 41-43 record and 4.56 ERA. In 1957 at age 51, he returned for one appearance with Portland and took a loss. (Courtesy of the Christiansen Collection.)

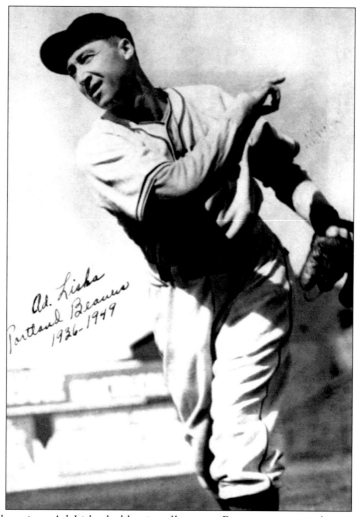

Venerable submariner Ad Liska holds virtually every Beaver career pitching record, among them 514 games, 339 starts and 198 wins from 1936 through 1949. He went 198-194 with a 3.21 earned run average in his 14 seasons, by far the greatest longevity of any Portland player. Liska, a righthander from Dwight, Nebraska, suffered a boyhood injury that prevented him from throwing overhand. After several seasons split between the majors and the minors, he arrived in Portland in 1936 and went 15-12 with a 2.91 ERA for that year's pennant-winner. That started an outstanding four-season run for Liska in which he went 75-64 with a 3.27 ERA; he had an even more dominant stretch from 1943-45, going 55-32 with a 2.26 ERA. In 1945, he went 20-12 with a 2.34 ERA as the Beavers won the pennant by 8$\frac{1}{2}$ games. "Ad Liska pitched out of the resin bag," catcher Charlie Silvera told Dick Dobbins in *The Grand Minor League*. "The first time I caught him, I said, 'Damn! I never saw the pitch.' He put the resin bag right there (where he would release the pitch). It took me a while to overcome that. I had to learn to follow the ball." At age 42 when he finished his final season, Liska went 4-11 on a sixth-place team but had an ERA of just 3.86; all four of his wins were over Oakland. Liska led the PCL with 24 wins in 1937, when he threw 319$\frac{1}{3}$ innings. He had seven shutouts in both 1937 and 1943. In 1946, he tossed a no-hitter in a 1-0, seven-inning win over the Hollywood Stars. During his career, Liska sold insurance in Portland during the offseason. After retiring, he lived in Portland. (Courtesy of the Larrance Collection.)

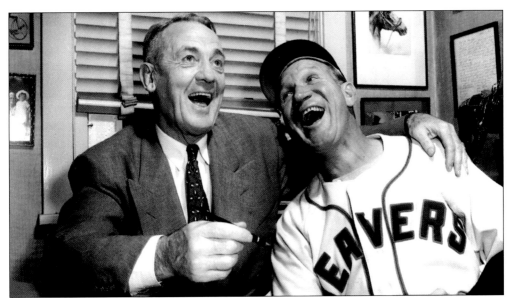

Bill Sweeney (right) shares a laugh or a song—or perhaps both—with Portland general manager Bill Mulligan. Sweeney served two terms as Portland manager; the first from 1936 through 1939 was as a player-manager, and then he again managed from 1949 through 1951. Early in the 1936 season, manager Max Bishop was fired in a dispute with the owners and was replaced by first baseman Sweeney; Portland went on to win the Pacific Coast League pennant. Sweeney played in the big leagues for the Detroit Tigers in 1928 and the Boston Red Sox in 1930 and '31. He also won Pacific Coast League pennants with Los Angeles Angels in 1943 and '44. Check out Sweeney's company on the list of PCL managers for 1951: Rogers Hornsby in Seattle, Joe Gordon in Sacramento, Mel Ott in Oakland, Lefty O'Doul in San Francisco, Fred Haney in Hollywood, Stan Hack in Los Angeles, and Del Baker in San Diego. (Courtesy of the Eskenazi Collection.)

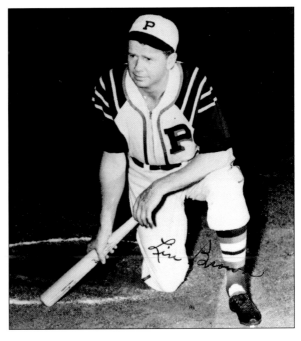

In 1940, Portland's uniforms became the Beavers' coat of many colors. Here, the striped sartorial statement is being worn by Lindsay Brown. Brown played shortstop for the Beavers from 1940 through 1942; after World War II, he returned in 1946. He was the definitive light-hitting infielder, batting .216 for the Beavers and, in 2,088 at-bats for Portland, he never homered. A career minor leaguer, Brown did put in 48 games for the Brooklyn Dodgers in 1937 and batted a respectable .270. Brown finished his playing days in 1949. (Oregon Historical Society neg. ORHI 085306.)

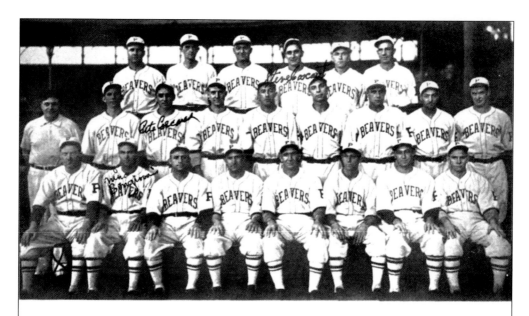

CHAMPIONS PACIFIC COAST LEAGUE – 1936

Top Row — Left to right: "Hobo" Carson, Tom Flynn, Steve Larkin, Steve Coscarart, Earle Brucker, "Moose" Claybaugh.

Middle Row — Left to right: Doc Meikle (Trainer), Bill Posedel, Pete Coscarart, Don French, Art McDougall, Fred Bedore, Bill Radonits, Johnnie Frederic, George Caster.

Bottom Row — Left to right: Bill Cronin, Nino Bongiovanni, Eddie Taylor, Goldie Holt, Bill Sweeney (Mgr.), Dudley Lee, Ad Liska, Sam Samhammer.

The pennant-winning Beavers of 1936 crossed the wire just 1 1/2 games in front of both Oakland and San Diego, and they did it in comeback fashion. Wrote L.H. Gregory of *The Oregonian*, "If this had been a seven-inning league, the Beavers would have finished about seventh. In at least half their games they were behind until the seventh or later. What won the pennant and made the fans so goggle-eyed with excited enthusiasm that in five playoff games they turned out just a few hundred short of 50,000 paid attendance was their terrific custom of landing on top in wild, hair-raising finishes." Outfielder Moose Clabaugh (top row, far right) provided the power with 20 home runs and 112 runs batted in while hitting .317. Outfielder-first baseman John Frederick (middle row, second from right) hit .352 with nine homers and 103 RBIs and first baseman-third baseman Fred Bedore (middle row, fourth from right) hit .337 with four homers and 100 RBIs. Portland swept Seattle in four games in the first round of the Pacific Coast League playoffs, then took Oakland in five games to add the postseason title. Pitcher George Caster (middle row, far right) led the PCL in wins with a 25-13 record and also topped the league with 234 strikeouts. His reward was a promotion to major leagues—or at least the last-place Philadelphia Athletics; he eventually played for 12 seasons in the big leagues, mostly with bad teams, and compiled a 76-100 record. Caster pitched for the St. Louis Browns' only pennant-winner in 1944 and made a mound appearance for the victorious Detroit Tigers in the 1945 World Series. Nino Bongiovani (front row, second from left)—nicknamed "Bongo"—played for the Beavers from 1934 through 1937. In 1937, he had the best year of his career as he led the PCL in at-bats (734), runs (136) and hits (236) while compiling a .322 batting average. He got his first taste of the major leagues in 1938, playing two games for the Cincinnati Reds, and then 66 games for the pennant-winning 1939 Reds. After World War II, he played for several teams in the lower minors in California until calling it quits after the 1949 season. (Courtesy of the Ranta Collection.)

Roy Helser—a hometown boy, born in Portland— had one of the longest and most illustrious careers in a Beaver uniform, pitching from 1942 through 1952 and making 245 starts. The lefthander had a 122-105 career record; from 1944 through 1946 he won 20 games each season and never pitched fewer than 270 innings. His numbers in that stretch were 20-16 with a 2.41 earned run average in 1944, 20-14 with a 3.37 ERA for the 1945 pennant-winners, and 20-16 with a 3.04 ERA in 1946. "He was a hard worker, so serious when he got in the ballgame," teammate Duane Pillette told Dick Dobbins in *The Grand Minor League*. "For a guy who was free and easy and loose when he wasn't pitching, kidding and laughing on the bench, he was the most serious pitcher I've ever seen. Very intense." Also, Eddie Basinski called Helser "one of the best hitters I've ever seen." Starting with that string of 20-win seasons, Helser won at least 10 games for seven straight seasons. That included a 16-10 mark with a 2.94 ERA in 1949, when he was named to the Pacific Coast League all-star team. Helser—also known for a terrific singing voice—didn't play competitive sports in high school but earned college letters in football, basketball and baseball at Linfield after being urged by coach Henry Lever to turn out. His minor league career moved to Salem in 1940, when he went 16-10 on the mound while batting .297 with four homers. He improved that to 15-3 for Salem in 1941 and also went 1-1in the PCL for San Francisco that season. With the onset of World War II, Helser was inactive for most of the 1942 and '43 seasons but managed a 3-3 record for the Beavers in that time; he was also 12-0 for Albina in the Shipyard League in 1943. After leaving professional baseball, Helser returned to Linfield to coach and he led the Wildcats to the 1966 NAIA national championship. He also guided the Drain Black Sox to the National Baseball Congress championship. (Courtesy of the Larrance Collection.)

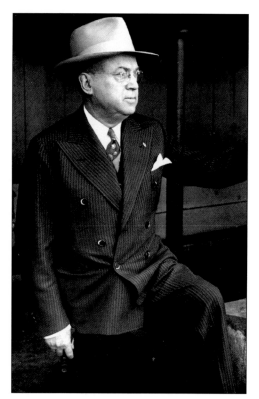

William Klepper headed a group that bought the Beavers from E.J. Schefter in 1942. Klepper was no newcomer to the Pacific Coast League or Portland, though, having previously owned the Beavers from 1921 through 1925 and also having been president of the Seattle franchise in the PCL's early days. In his second stint in Portland, Klepper also served as general manager and built the Beavers' 1945 pennant-winners. Klepper sold his interest in the team in 1946 and retired from baseball. Klepper's original ownership of the team came when he purchased the Beavers from the McCredie family. That stewardship also brought him to the attention of Judge Kennesaw Mountain Landis, the commissioner of baseball. Just before leaving Seattle, Klepper released a number of talented players; upon arriving in Portland, Klepper signed them to contracts with the Beavers. Landis suspended Klepper, who then went to court and had the action overruled; it is supposedly the only time Landis ever had one of his baseball rulings overturned. (Courtesy of the Eskenazi Collection.)

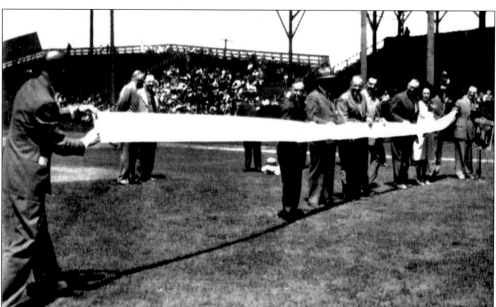

In 1943, radio station KXL sold in excess of $300,000 worth of War Bonds—enough to build a bomber, which was to be known as "The Lucky Beaver." In this photo, a 28-foot-long scroll containing the names of the 5,000-plus bond purchasers is presented to the State Bond Administration. The ceremony took place at home plate at Vaughn Street prior to a home game. (Courtesy of the Larrance Collection.)

For the last three years of World War II, the cover of Portland's program featured Uncle Sam and the war effort; in 1945, the Beavers completed a four-year first-to-last climb to win the Pacific Coast League pennant. Inside, an advertisement for the Durham & Bates insurance agency included a ballot for fan to elect the Portland's most popular player; the winning player would receive a $100 War Bond. On the next page, the Commercial Iron Works advertised, "PLAY BALL! with the men on the firing line. Men needed at once to build and repair fighting ships for the U.S. Navy!" (Courtesy of the Larrance Collection.)

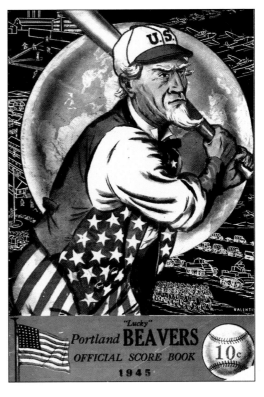

Rupert Thompson was an outfielder for Portland from 1941 through 1943; he was once swallowed up by a sinkhole in centerfield at Vaughn Street while closing in on a fly ball during a game in the early 1940s. Thompson claimed he'd caught the ball, but he didn't have a witness. The sinkhole resulted from a collapse of a portion of the drainage system. Thompson is shown here with Dick Benevento, the son of longtime Beavers groundskeeper Rocky Benevento who was serving as the visiting team's batboy. (Courtesy of the Benevento Collection.)

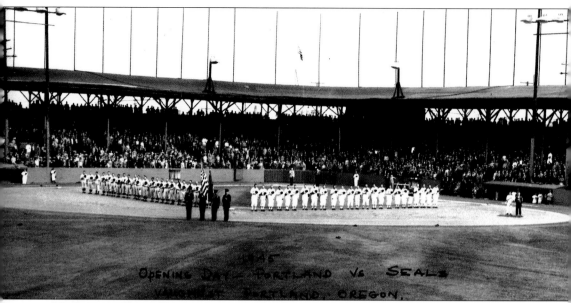

It's Opening Day at Vaughn Street for the 1945 season, with the Beavers and the Hollywood Stars on the field for pregame ceremonies; the photographer has mislabeled the opposition as the San Francisco Seals. Portland had already posted a 12-4 record on its season-opening road trip, and the Beavers continued their drive to the pennant despite losing that afternoon to the Stars by a 2-1 score. Portland pitcher Ad Liska had taken a shutout into the ninth inning before the Stars broke through in front of a crowd of 12,641. (Courtesy of the Ranta Collection.)

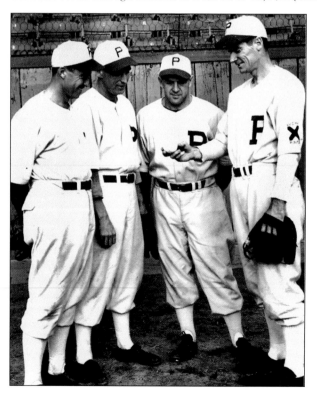

Don Pulford (second from left) pitched for the Beavers from 1944 through 1946, with part of the 1946 season spent with Seattle, posting a 28-33 record and 4.92 earned run average in those seasons. He went 20-11 with a 2.37 ERA for Portland's 1945 p ennant-winner, combining with Ad Liska (far left) and Roy Helser (third from left) for a top-flight trio of starters for manager Marv Owen (far right). Pulford spent 11 years in the minor leagues and bounced from coast to coast, wrapping up his career with Mexicali of the Sunset League, but he never made it to the major leagues. (Courtesy of the Eskenazi Collection.)

40

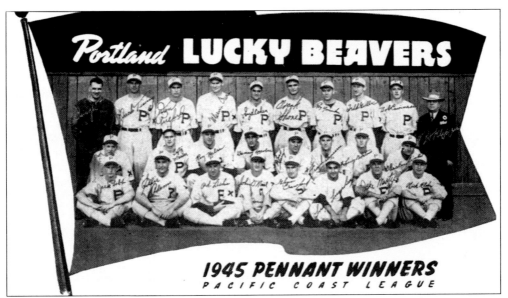

In 1945, Portland completed a four-year, last-to-first climb by winning the Pacific Coast League pennant by 8½ games over Seattle. The Beavers' 112-68 record gave them a .622 winning percentage, the club's best since the 1906 champs won at a .657 pace. Portland split its season series with Los Angeles, but had a winning record against every other PCL club. Player-manager Marv Owen (back row, fourth from left) batted .311 while manning third base; first baseman Larry Barton (middle row, second from right) hit .318 with six homers; and shortstop Robert O'Neil (front row, fouth from left) led the PCL with 13 triples for a club that batted just .237 as a team and didn't have a player reach double digits in home runs. The Beavers had a trio of 20-game winners in Ad Liska (front row, third from left, 20-12 record), Burt Pulford (back row, third from left, 20-11 record) and Roy Helser (middle row, third from left, 20-14 record). (Courtesy of the Larrance Collection.)

Admit One

PORTLAND LUCKY BEAVER

Pennant Winning Baseball Banquet

MONDAY, SEPTEMBER 24, 1945

6:30 P. M.

Portland saluted its 1945 Pacific Coast League champions with a banquet at the Multnomah Hotel. Oregon Governor Earl Snell was on hand to present commemorative watches and a special gold-and-diamond ring to each player. The ballclub provided the rings, but the watches were the result of L.H. Gregory of *The Oregonian* urging fans to contribute to a special fund for the purpose at First National Bank; Gregory felt it had not been right that the players from Portland's 1936 championship team received no memento of their victory. (Courtesy of the Christiansen Collection.)

Marv Owen played first base and third base for the Beavers from 1941 through 1946 and was also manager for the 1944 through 1946 seasons. He led Portland to a second-place finish in 1944, and then guided the 1945 pennant-winner that lost in the playoffs to San Francisco. Owen hit over .300 in his six-year Beaver career, including a .311 mark in 1945 when he was 39 years old. Owen played over 1,000 games in the major leagues for the Detroit Tigers, Chicago White Sox and Boston Red Sox from 1931 through 1940. He is best remembered for a play in the final game of the 1934 World Series, when the St. Louis Cardinals' Ducky Joe Medwick slid particularly hard into third base, tangling with Owen. When Medwick returned to the outfield in the following inning, irate Tigers fans pelted him with debris, and Commissioner Kennesaw Mountain Landis removed Medwick from the game "for his own safety." (Courtesy of the Larrance Collection.)

George Norgan was a Canadian who was part of the group headed by William Klepper that bought the Beavers in 1942. After the pennant-winning season of 1945, Norgan bought out Klepper and became the Beavers' owner. The Norgan era brought about some of Portland's best-ever marks for season attendance, saw the development of a statewide radio network and fielded teams that may not have won pennants but were competitive in an era when the Pacific Coast League sought status as a third major league. As The Oregonian sports editor L.H. Gregory noted, "Mr. Norgan had been a pretty good owner, but being an absentee was too much of a handicap." After Portland's last-place finish in 1954, Norgan sold the team into community ownership; the ballclub was run by a board of directors, but shares of stock in the club sold for $10. (Courtesy of the Larrance Collection.)

FOUR

Rocky and Rollie

In all the years, in all the cities where minor league baseball has been played, few individuals—if any—have matched the length or level of service that Rocky Benevento and Rollie Truitt provided the Portland Beavers. Both Benevento, the head groundskeeper, and Truitt, the radio broadcaster, were with the team from the late 1920s into the 1960s.

In a business where the players, managers and owners often change every few seasons, Benevento and Truitt were the constants that linked the Beavers to their fans.

Benevento arrived for the 1927 season and worked through 1966; his tenure lasted through 30 managerial changes and five ownership changes. Truitt's era from 1929 through 1963 included 28 managerial changes and the same five ownership changes. Both spanned the Beavers' move from Vaughn Street to Multnomah Stadium.

Benevento was born in Tricario, Italy in 1897 and his family moved to California. In 1927, Portland general manager Tom Turner lured Benevento from his job at the ballpark in San Jose and Benevento drove north in his old pickup to take on the challenge of keeping Vaughn Street in suitable playing condition. His job eventually included simply being himself to make friends for the ballclub.

When Benevento passed away in 1969 at age 71, *The Oregonian* noted: "He adored kids … he loved baseball . . . and most of all he loved people.

"Benevento became an institution in his own right. The little fellow with the wide grin was never without his trusty rake. He was a colorful character, who knew how to 'ham' it up during dull spots of a baseball game—and the crowds loved his antics . . . during televised games of the Beavers, he'd deliberately take his rake to one of the bases and start raking the infield dirt. Knowing the TV cameras were focused on him, he'd dilly-dally until the umpires practically had to usher him off the field. And the audience would roar its approval of Rocky's antics."

Following the 1956 season, the fans of Portland took up a collection and sent Benevento to the World Series. During the 1960 Rose Festival, Benevento was asked to show up at the Sheraton Hotel; he arrived in his trademark white coveralls with Portland's "P" on the left chest, thinking he was posing for publicity photos with the Beavers. Instead, he found himself named Portland's first "King of Fun" to reign over the festival.

Benevento's contributions to the game in Portland included the number of youngsters he hired to help keep Vaughn Street maintained, allowing them to work out on the field when the Beavers were on the road. *The Oregonian* also mentioned that Benevento appeared at "banquets, children's Christmas parties . . . [he] helped Little Leaguers get their fields in shape or represented the baseball club at a funeral . . . he was a man with a sunny disposition, a quick, infectious smile, a ready wit and a wholesome love of clean fun and frolic." The site of the former ballpark in northwest Portland is now a parking lot, but on the brick wall surrounding it is a plaque saluting Benevento for his efforts on behalf of baseball in Portland.

Players enjoyed the occasional practical joke at Benevento's expense. Once it consisted of burying a large rock in the infield with just the tip exposed; after Benevento was fetched to eliminate the impediment, he had to keep digging and digging with the players watching in amusement.

Benevento had moneymaking ventures apart from his groundskeeping. At one time in the 1940s, his family owned and ran a spaghetti restaurant just up Vaughn Street from the ballpark. Benevento also took broken bats and turned them into lamps for players, charging them "maybe a dollar-and-a-half," former Beaver Nino Bongiovanni told Dick Dobbin in *The Grand Minor League*. During the holidays, Benevento also worked as a department store Santa Claus.

At ceremonies honoring his retirement at the end of the 1966 season, Benevento entered Multnomah Stadium riding an antique car, wearing red-and-white-striped coveralls, rake in hand. He was presented with a new car that afternoon.

Benevento went on to serve as groundskeeper at Multnomah Kennel Club. He had a special box to watch the Beavers. His funeral brought an overflow crowd to St. Patrick's Catholic Church, and among those attending was Gov. Tom McCall.

Vince "Pesky" Paveskovich, one of the neighborhood kids who had been befriended by Benevento, told the Northwest Examiner newspaper years later: "He could have run for mayor and he'd have won."

Tuitt's route to Portland wasn't as long as the one Benevento traveled. Arthur Rolland Truitt was born in Boulder, Colorado, in 1901 and his family moved to a farm in Douglas County, Oregon, in 1911. It was here, via a crystal set, that he first heard Sid Goodwin broadcasting Portland baseball, with Goodwin's cries of "Oh, lady! Oh, lady!" when the Beavers came up with a great play or a home run.

Truitt graduated from Oakland High in 1921 and studied journalism at the University of Oregon but moved to Portland in 1923, entering the Behnke Walker Business College. From there, he worked stints behind a grocery counter, at a boiler factory, as a garage attendant and as a warehouseman.

In 1926, Truitt started in radio at KXL. As he described it later, he was "time salesman, disc jockey and general handy man." In 1929, KXL took over the baseball broadcasts because KGW had switched to network programming and Truitt was handed the assignment of describing the games.

"What a job for a guy who had never played baseball!" Truitt wrote in 1953. "Between Western Union operators Fred Wegner and Ralph Coffin, plus a lot of help from Mrs. T, who knew more about baseball than I did, I finally learned to decipher the abbreviations and faced a critical baseball audience with a hope and a prayer."

At that point, the Beavers' owners would only allow re-creations of road games; no home games were broadcast. In 1933, when the broadcasts—and Truitt—moved from KXL to KEX, the Beavers began allowing the last three innings of each home game on the air before opening up to full-time broadcasting in 1936. Road games were still done via re-creations, as a deal with General Mills made Wheaties the first full-time sponsor of Beaver radio.

The re-creations didn't include sound effects until 1937, and Truitt wasn't a big fan of using them.

"In those days we did not have tape recording where you could take a machine out to the games and record the actual sounds of a baseball crowd," Truitt wrote. "All the ones available to us were commercial recordings. The ones Bill [Adams, his broadcast partner] and I used to give some semblance of authenticity to the baseball games were reproductions of a football crowd at Chicago's Soldier Stadium [100,000 strong]. You can imagine the din when Moose Clabaugh or Nino Bongiovanni of that year's club socked a home run and Bill turned that crowd of 100,000 loose."

During some of those years, Truitt's schedule for a typical week included seven baseball broadcasts, two wrestling matches and a boxing match. His career also included broadcasting hockey and football.

In 1944, there were no broadcasts for the first six weeks of the season until the Davidson Bread Company signed on, starting what was to become a long-term commitment to Beaver baseball.

That was the year that Truitt—by now acclaimed as "The Dean of PCL Broadcasters"—left the KXL staff to work as a freelancer.

For one game in 1952, Truitt and broadcast partner Bob Blackburn took a re-creation to the fans, doing a game from the livestock pavilion at the Lincoln County Fair in Newport.

In the 1953 *Rollie Truitt Silver Anniversary Scrapbook*, Truitt thanked "Mrs. T"—his wife, Dorothy—for her help through the years, acknowledging she "keeps the daily record on nearly two hundred ball players" and supervises Rollie Truitt's Smoke Shop, which was located in a downtown hotel.

Truitt broadcast the Beavers through the 1963 season, then served as the team's public address announcer. He continued going to games all the way through the 1972 season; he died later that year at age 71. In his obituary, the *Oregon Journal* noted, "He was a good-natured man who had a lot of friends and that wonderful quality which enabled him to laugh at his own mistakes ... he made numerous appearances around the state for the baseball club. There was hardly an old-time Beaver baseball fan who hadn't spoke with Truitt at some time or another."

Added George Pasero of the *Oregon Journal*: "Rollie was a friend to all; he never cut people, never knocked. And he always tried to help ... it can really be said that there are too few around like him."

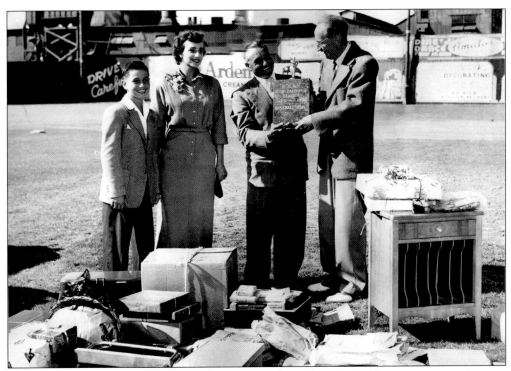

One Portland baseball legend helped honor another when Rocky Benevento was given a day in his honor at Vaughn Street during the 1950 season. Broadcaster Rollie Truitt presents Benevento with a plaque as his son, Dick, and daughter, Margaret Ellen, stand with the day's gifts on the field at Vaughn Street. The occasion—noted on the plaque—was in honor of Benevento's 25 years of service to baseball from 1925 to 1950; that must have figured in two years at Benevento's prior job in San Jose before moving to Portland in 1927. By that time, Truitt was also an institution in Portland, having been the Beavers' broadcaster since 1929. (Courtesy of the Benevento Collection.)

(*above, left*) Rocky Benevento passes along a few tips on bunting to his son, Dick, in the 1950s. Dick Benevento, a second baseman and, by his own description, "a helluva hitter," played for Central Catholic High and went on to play for the University of Portland. (Courtesy of the Benevento Collection.)

(*above, right*) One of Rocky Benevento's side ventures was turning bats into reading lamps for the Beavers and players from other Pacific Coast League teams; this is a flyer that Benevento sent out to solicit some light business during his non-groundskeeping hours. (Courtesy of the Benevento Collection.)

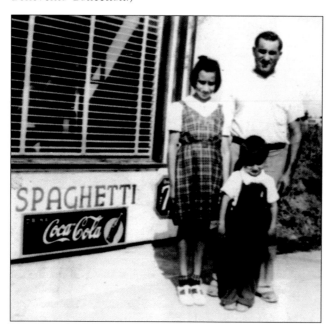

For a time in the 1940s, the Beneventos owned and operated a spaghetti restaurant just up Vaughn Street from the ballpark; here are Rocky, daughter Margaret Ellen and son Dick in front of the establishment. The family also frequently had ballplayers from both the Beavers and visiting teams in their home for meals. Longtime Beavers fan Art Larrance remembers meeting Joe DiMaggio and having the Yankee Clipper tell him that what he recalled about Portland from his days as a San Francisco Seal was "the groundskeeper who would have us over, and he made great spaghetti." (Courtesy of the Benevento Collection.)

Someone has written 1954 on the photo, but it was after the 1955 season that the Beavers moved from their longtime home at Vaughn Street to Multnomah Stadium. Rocky Benevento loads a barrel of bats for the short trip to the team's new ballpark. (Courtesy of the Benevento Collection.)

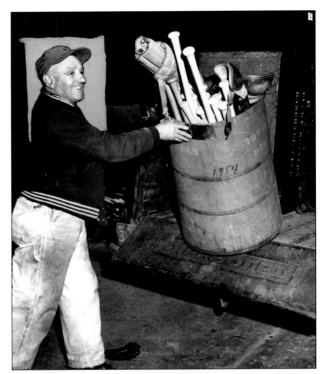

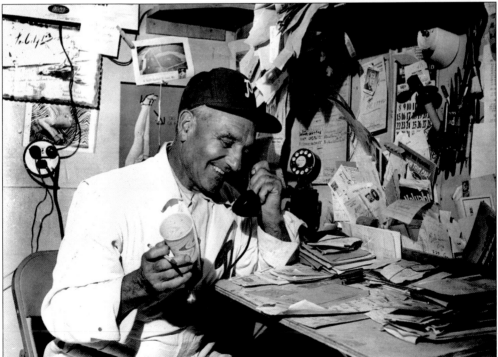

The calendar on the wall says 1957, which would mean this was Rocky Benevento's office at Multnomah Stadium in only the Beavers' second year at the ballpark. For just two seasons, that's quite an accumulation of items surrounding Benevento. (Courtesy of the Benevento Collection.)

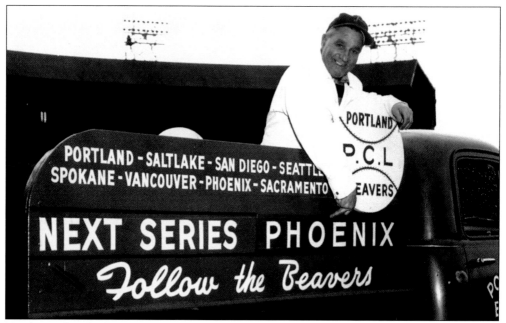

Not long after the Beavers moved to Multnomah Stadium, the pickup that Rocky Benevento used to work on the diamond was turned into a portable advertisement of the team's coming attractions. (Courtesy of the Benevento Collection.)

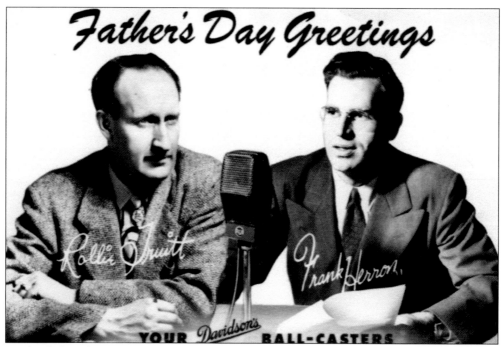

Portland's broadcasters—Rollie Truitt and Frank Herron—offered these postcards at a Father's Day game in the late 1940s. Herron, who was from Port Angeles, Washington, worked with Truitt for three seasons from 1947 through 1949 on the Beavers' broadcasts. (Courtesy of the Larrance Collection.)

By 1955, Truit's Beaver baseball broadcasts were being carried statewide over a 14-station radio network that was one of the largest in the minor leagues. Baseball broadcasting in Portland dated back to the early 1920s and moved from one station to another—including KTBR, KGW, KXL, KWJJ and KVAN—over the next several decades. The network was formed with three stations in 1950 and quickly grew to 12 stations the next season. (Courtesy of the Larrance Collection.)

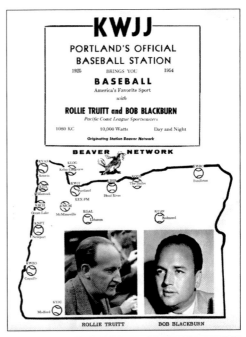

From 1948 through 1956, Rollie and Dorothy Truitt annually published *Rollie Truitt's Scrapbook*, a complete guidebook to that year's team. The books contained photos and complete career records of players and coaches, brief biographies of front office personnel and Pacific Coast League umpires, and information on the rest of the PCL's teams. (Courtesy of the Larrance Collection.)

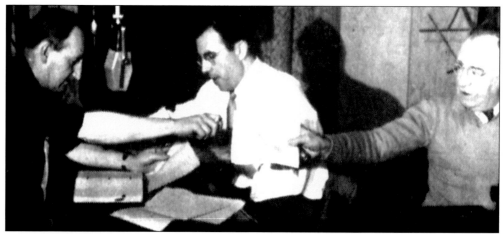

This typical studio scene during a re-creation of one of the Beavers' road games shows (left to right) Rollie Truitt announcing, Frank Herron preparing for a commercial, and telegrapher Fred Wegner handing some play-by-play to Truitt. (Courtesy of the Larrance Collection.)

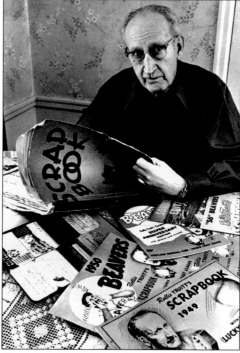

(*above, left*) For many years, Rollie Truitt's broadcast position at Vaughn Street was located in the grandstand behind home plate, putting him in close proximity to the fans. Truitt later wrote, "The writers and broadcasters sat in the open with only an iron railing separating them from the rabid fans. Sometimes the roar of the crowd was greater than the volume of the words going into the microphone and I used to wonder how those writers could work with all the confusion going on around them." (Courtesy of the Larrance Collection.)

(*above, right*) At his home in the 1960s, Rollie Truitt looks through mementos of the career that earned him the title "Dean of Pacific Coast League broadcasters." (Courtesy of the Eskenazi Collection.)

FIVE

1946–1957
Middle of the Pack in the Open Era

By 1946, World War II had ended and baseball and the country returned to normal. So did the Beavers, sinking to seventh place, 41 games out of first place, after three straight years in the playoffs. About the only bright spots that season were an Ad Liska no-hitter and Harvey Storey winning the Pacific Coast League batting title with a .326 average.

In 1947, Eddie Basinski, who had been keeping the Brooklyn Dodgers' shortstop job warm during the war for Pee Wee Reese, came to Portland. The Beavers finished third that year, losing to the Los Angeles Angels in the first round of the playoffs. Former Detroit Tiger star Tommy Bridges was initially declared the league ERA champ, but that was later rescinded when it was determined that he had too few innings to qualify. The team drew 421,000 fans, the most in the history of the franchise to that point; it would remain Portland's highest attendance until the current version of the Beavers occupied PGE Park in 2001.

Portland turned in another lackluster performance in 1948, finishing fifth and beginning a half-dozen year streak where the Beavers were simply an average team. The wonderfully named Fenton Mole led the team in home runs with 27.

Despite a sixth-place finish in 1949, Portland produced the PCL leader in wins with Harold Saltzman (23) and had pitcher Roy Helser selected to the all-star team. The ongoing story that year was the integration of the Pacific Coast League. Portland was one of the teams that stepped up to the plate, as Frankie Austin and Luis Marquez joined the team. Austin fit in right away, as he and Basinski were an excellent keystone combo; decades later, Basinski remained full of praise for Austin. For Marquez, it was a little slower. His quiet manner was initially perceived as aloofness, but the ice soon thawed and Marquez turned out to be a real cheerleader on the bench.

The 1950 season began a four-year run that was, if nothing else, consistent—four consecutive fourth-place finishes, between 14 and 17 games out of first place each year, the Beavers winning a total of eight more games than they lost over that span.

In 1951, Portland made its only trip to the playoffs in the '50s, losing to Hollywood in the first round. Joe Brovia continued to pound the ball and was the team's hitting star, as he had been the year before. 1952 was notable for the arrival of Clay Hopper, who began a four-year stint as Beaver manager. Hopper is best remembered as Jackie Robinson's manager at Montreal in 1946. It also marked the first season that the Pacific Coast League was granted "Open" status—a step above the other Triple-A leagues, but a step below the majors. In 1953, the team announced plans for a new ballpark, with plans drawn for a new facility at 82nd and Holgate. The plan never got off the ground, a victim of the Korean War and other factors.

In 1954, Portland lost its stranglehold on fourth place—by dropping to eighth. No pitcher on the team won more than 12 games, and no regular hit .300. The season ended fittingly

when Roger Bowman of Hollywood, who led the league in wins that year, threw a seven-inning perfect game against the Beavers on the last day of the season. It was a game Hollywood had to win to tie for pennant.

After the 1954 season, the team was sold to the community via public stock subscription. The 1955 edition of the team rewarded its 2,400 new owners by jumping up to fifth place, finishing only nine games back of champion Seattle. No player had more than 87 RBIs, but 10 players had at least 30. Similarly, the pitching had no great stars but was generally solid. Attendance, which had dropped dramatically over the previous two seasons, rebounded nicely.

The Beavers moved from Vaughn Street to Multnomah Stadium in 1956 and also continued their improvement, moving up to third place even though their record wasn't quite as good as the year before. Rene Valdez led the PCL in victories with 23 and Valdez, Marquez, and Jack Littrell made the all-star team. The year started off with a bang as the Beavers drew 34,450 to a day-night doubleheader in their first appearance at Multnomah Stadium.

The 1957 season marked the end of the "classic" Pacific Coast League. When the Dodgers and Giants moved west, it removed the league's two largest cities, Los Angeles and San Francisco. Portland ended the era with another trip to the PCL cellar, 41 games behind San Francisco.

The league would henceforth be subject to frequent and dramatic change, but Portland endured.

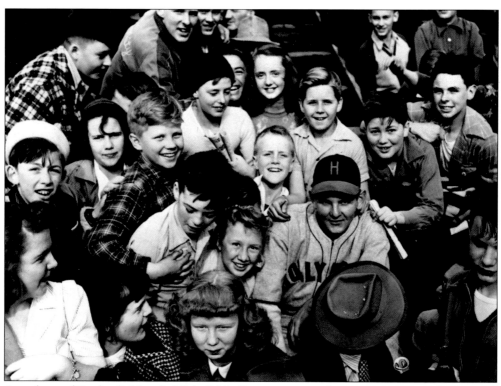

A graduate of Portland's Lincoln High, Eddie Erautt was one of many youngsters nudged toward a baseball career by longtime Beavers groundskeeper Rocky Benevento; here, he's the center of attention of Vaughn Street fans prior to Portland's 1946 home opener against Hollywood. The fans enjoyed the day more than Erautt, as the Beavers took a 5-2 win. Erautt reached the Pacific Coast League with Hollywood, San Diego, and Vancouver. Erautt was in the Major Leagues from 1947 through 1952 with the Cincinnati Reds and St. Louis Cardinals, going 15-23 with a 4.86 earned run average. (Oregon Historical Society neg. ORHI 091676.)

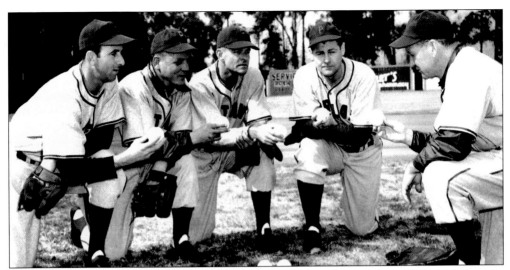

Jake Mooty (second from left) pitched for the Beavers from 1945 through 1949, going 44-59 with a 4.08 earned run average. In helping Portland to the 1945 Pacific Coast League pennant, Mooty went 11-5 with a 3.12 ERA and 12 complete games. By then, the righthander from Bennett, Texas, had pitched all or part of seven seasons in the major leagues with the Cincinnati Reds, Chicago Cubs and Detroit Tigers, going 16-23 with a 4.03 ERA. This gathering at the Beavers' 1949 spring training camp in Riverside, Calif., includes (left to right) Vince Dilassi, Mooty, Tommy Bridges, Bill Fleming and Bill Sweeney. (Courtesy of the Eskenazi Collection.)

When the 39-year-old Thomas Jefferson Davis Bridges arrived in Portland in 1947, he was a six-time major league all-star with 194 pitching wins. A star pitcher for the Detroit Tigers in the 1930s, Bridges was a 20-game winner three times and led the American League in strikeouts twice. He pitched in the World Series in 1934, '35, '40 and '45. With Portland from 1947 through 1949, Bridges went 33-25 with a 2.96 earned run average. In one of his first starts for Portland, he no-hit San Francisco. He finished 1947 with a 7-3 record and his 1.64 ERA was the lowest in the league but he hadn't pitched enough innings to qualify for the ERA title. In 1948, he went 15-11 with a 2.86 ERA. Bridges finished his career with Seattle in 1950. Bridges had a reputation for throwing a spitball, but that wasn't actually one of his pitches—he reportedly preferred to doctor the baseball with pine tar. (Courtesy of the Larrance Collection.)

The Beavers typically played a game or two each season against their farm club, the Salem Senators. Early in the 1946 season, Salem manager Leo "Frisco" Edwards suffered a fatal heart attack, leaving a widow and a four-year-old son, Tommy. On July 15, Portland traveled to Waters Park in Salem to take on the Senators, and an overflow crowd of 7,500 attended to pay tribute to the former manager and to raise money for an education fund for Tommy. Over $10,000 was raised as Carl Mossor one-hit the Senators in a 5-0 Beaver victory. (Courtesy of the Larrance Collection.)

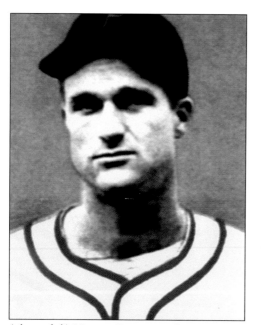 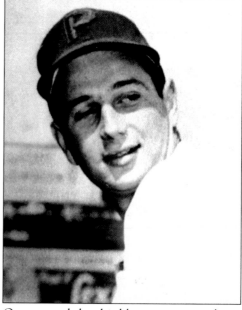

(above, left) Harvey Storey was born in Gaston, Oregon, and the third baseman was a classic career Pacific Coast League player—he never made it to the major leagues, but played 1,275 games for Portland, San Francisco, Los Angeles and San Diego from 1936 through 1952. He was with the Beavers from 1946 through 1949, batting over .300 with at least 14 home runs in each of those seasons; he won the PCL batting title in 1946 with a .326 average while splitting the season between Los Angeles and Portland. (Courtesy of the Larrance Collection.) (above, right) Harold Saltzman pitched in just eight games for the Beavers in 1948 and won his only decision, but the righthander hit it big in 1949, going 23-13 to tie for the Pacific Coast League lead in wins. He was a Portland native, graduating from Lincoln High, and later played college baseball at both Oregon and Southern California. (Courtesy of the Larrance Collection.)

Fans line up to buy their tickets for the 1947 home opener at Vaughn Street. The Opening Day crowd of 14,854 was the largest for any Pacific Coast League home opener, and it was also the second-biggest crowd ever at Vaughn Street up to that point. The gathering saw Oregon Governor Earl Snell throw out the first pitch, then watched the Beavers beat defending PCL champion San Francisco 1-0 as Roy Helser and Ad Liska combined on the shutout. As was customary at the time, players earned prizes for the home season's various "firsts." Second baseman Bob Gorbould picked up a dozen golf balls for the first hit and a hat for the first sacrifice, shortstop Joe Dobbins got a sport shirt for the first run, third baseman Harvey Storey a hat for drawing the first walk, first baseman Herm Reich a lighter for handling the first infield putout and leftfielder Johnny Lazor a box of cigars for catching the first flyout. The Opening Day crowd started an unprecedented rush through the gates of the Portland ballpark, as the season attendance of 421,137 was a new record; the Beavers wouldn't again draw that many fans in a season until the city's 2001 return to the PCL. (Oregon Historical Society neg. ORHI 58937.)

In the late 1940s, it wasn't uncommon for Portland businesses to use their display windows to salute the Beavers—especially when it came to getting ready for Opening Day. This is how Flowers Tommy Luke promoted one year's home-opener. (Courtesy of the Benevento Collection.)

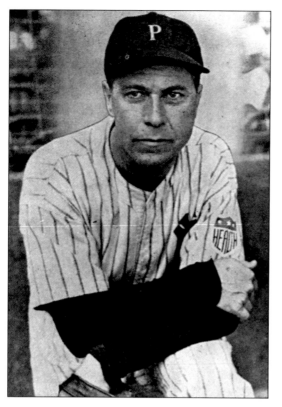

Jim Turner managed Portland to third place in 1947 and fifth place in 1948. He was nicknamed "Milkman Jim" because he worked on his family's Tennessee dairy farm in the winters. He came to the Beavers after managing Beaumont in the Texas League in 1946, then left Portland in 1949 to become the New York Yankees pitching coach until 1959, then again from 1966 through 1973. Turner had broken into the majors with the Boston Braves in 1937 at age 33, won 20 games and led the National League with a 2.38 earned run average. He eventually pitched for the Cincinnati Reds' 1940 World Series champions but was never again a 20-game winner. In his final season, at age 42 for the 1945 Yankees, he led the American League with 10 saves and prompted manager Joe McCarthy to say, "He knows all there is to know about pitching." Note that the photo of Turner shows him in a Yankee uniform; the Portland "P" has been airbrushed onto his cap. (Courtesy of the Carlson Collection.)

Tip Berg became the Beavers' trainer in 1948, eventually adding the duties of traveling secretary. Originally from North Dakota, Berg headed west and found work in the Idaho mines; he attended school at night to acquire an education in physical therapy and dietetics. He carried on his studies while in the U.S. Army, working in shipyards and as a salesman before being hired by the Tacoma hockey club in 1947; he was hired by Tacoma's ballclub in the Western International League in 1947. Berg suffered an embarrassing moment during his initial spring training session with the Beavers—the first time he faced the team to lead them in calisthenics, he dislocated his right arm. During his career, though, Berg became regarded as one of the top trainers in the Pacific Coast League. (Courtesy of the Larrance Collection.)

PORTLAND "LUCKY BEAVERS"—1947

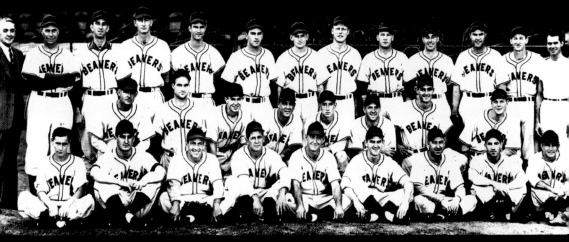

BACK ROW — Bill Mulligan, *General Manager* • Jim Turner, *Manager* • Vince DeBiasi • Duane Pillette • George Vico • Eldon Muratore • Ed Basinski • John Bianco • Jack Salveson • Herman Reich • Andy Sierra • Tedd Gullic • "Doc" Dick George.
2ND ROW — Tommy Bridges • Harvey Storey • Len Ratto • Jake Mooty • Ed Bahr • Roy Helser • Dick Wenner • Jack Robinson.
1ST ROW — Stanley Bozich, *Bat Boy* • Bill Radulovich • Joe Dobbins • John Lazor • Mayo Smith • Charley Silvera • Ad Liska • Ford Mullen • Danny Escobar

In 1947, the Beavers had a number of players who would be heard from later in their careers. Charlie Silvera (front row, fourth from right) caught for the Beavers in 1947 and '48, on loan from the New York Yankees. He hit just .247 in 1947, but bumped that to .305 while driving in 85 runs in 1948. Silvera would later draw some of the easiest World Series paychecks around, serving as Yogi Berra's backup for the Yanks from 1948 through 1956. Silvera played in precisely one World Series game—in 1949—despite the New Yorkers making seven trips to the Fall Classic during his tenure. Mayo Smith (front row, fifth from left) was in Portland as an outfielder from 1946 through 1948. He had his finest season for the Beavers in 1947, batting .311 with five homers. He later spent nine seasons as a big league manager between 1955 and 1970 for the Philadelphia Phillies, Cincinnati Reds and Detroit Tigers. He piloted the 1968 Tigers to the World Series title. His namesake, The Mayo Smith Society, is a large group of expatriate Detroit Tiger fans. Incidentally, Smith's given name was Edgar. Vic Raschi (not pictured) was also on loan from the Yankees. He was 8-2 with a 2.75 earned run average for the Beavers, and his recall to New York during the season may have cost the Beavers the pennant—they placed third in the Pacific Coast League, just 8½ games out of first place. After going up to the Yanks, Raschi had a 7-2 record during the remainder of the season. Also on that team was Jack Salveson (back row, fifth from right), who pitched for the Beavers in 1946 and '47 and went 32-28 with a 3.09 earned run average. He was noted for throwing strikes—concessionaires didn't necessarily like him, because games as brief as 90 minutes were common during his starts. Salveson gave the vendors plenty of time to do business during one 1947 game, though—he threw a 20-inning shutout to beat Sacramento 1-0. Prior to pitching for Portland, he had spent parts of six seasons from 1933 through 1945 in the major leagues with the New York Giants, Chicago White Sox, Pittsburgh Pirates and Cleveland Indians, going 9-9 with a 3.99 ERA; he had been the last rookie signed by legendary Giants manager John McGraw. (Courtesy of the Larrance Collection.)

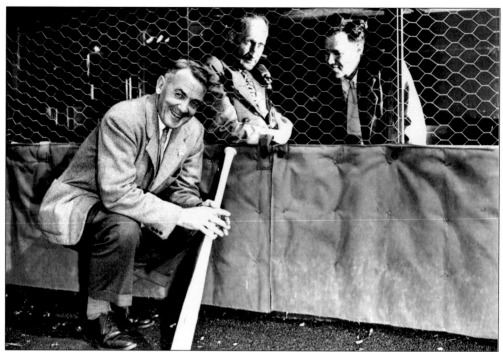

Portland general manager Bill Mulligan (left) visits the Vaughn Street press box to chat with broadcasters Rollie Truitt (center) and Frank Herron. Mulligan was a Gonzaga graduate and Seattle's general manager before coming to Portland in 1947; he'd been named the Minor League Executive of the Year in 1944 by The Sporting News. His move south helped heat up the Pacific Coast League's Pacific Northwest rivalry. Eddie Basinski told author Dick Dobbins in his book *The Grand Minor League*: "There absolutely was a rivalry between Seattle and Portland, and part of the reason was due to Bill Mulligan being canned by Seattle. He just hated them. He hated them with a passion. When he came to Portland, every time we beat Seattle it meant $25 for each player, so that helped our motivation." (Courtesy of the Eskenazi Collection.)

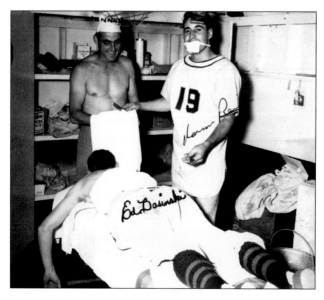

Just what seems to be ailing Eddie Basinski (lying down) isn't clear in this photograph from the late 1940s, but in their makeshift operating room in the Beavers' clubhouse at Vaughn Street, nurse Dick Wenner (left) and doctor Herm Reich (right) appear to believe they have the answer. (Courtesy of the Eskenazi Collection.)

First baseman Vince Shupe gives some tips on receiving throws at first base during a two-day baseball school at Vaughn Street in August 1949; the school was put on for many years by the Beavers and the Oregon School Activities Association. Among over 500 youngsters on hand were (left to right) Gordon Miller, 17, of Mills City, Oregon; Charles Brown, 16, of Portland; and Robert Baldridge, 14, of Vancouver, Washington. When Shupe came to the Beavers from San Diego in the middle of the 1949 season, his professional career dated back to 1939 included a stint in the major leagues with the Boston Braves in 1945. He hit .275 with eight homers and 81 RBIs for the 1949 season, then batted .279 with a pair of homers for Portland in 1950 before finishing the season with Oklahoma City in the Texas League to wrap up his career. (Oregon Historical Society neg. ORHI 57074.)

Johnny Rucker was a starting outfielder for the Beavers from 1948 through 1950, batting .298 and averaging just over 10 homers per year. Rucker played for the New York Giants from 1941 through 1946. His uncle was Nap Rucker, a star pitcher for the Brooklyn Dodgers early in the 20th Century. Rucker graduated from Georgia, where he earned four letters in baseball. According to a *Rollie Truitt Scrapbook* of the era, he was the only harmonica-playing stamp collector on the Beavers. (Courtesy of the Christiansen Collection.)

Frankie Austin, a Panama native, made his professional debut with the Philadelphia Stars of the Negro National League in 1944 and paced the circuit in hitting with a .390 average. While with the Beavers from 1949 through 1955, the shortstop played over 1,000 games for Portland; he batted .267 with 29 home runs and 358 runs batted in. His top seasons at the plate were 1951, when he hit .293 with four homers and 70 RBIs; and 1953, when he hit .280 with seven homers and 62 RBIs. Where Austin shone was in the field, though, combining with second baseman Eddie Basinski to form one of the Pacific Coast League's top keystone combinations. Austin and outfielder Luis Marquez became the Beavers' first black players when they joined the team in 1949 during a series at Hollywood. In 1955, during the Beavers' final day at Vaughn Street, Austin was named the team's Most Popular Player as a result of season-long voting by fans. Austin finished his PCL days in 1956 with Vancouver. (Courtesy of the Eskenazi Collection.)

Portland was just one of four stops that Joe Brovia made in the Pacific Coast League. Besides playing for the Beavers from 1949 through 1952, the outfielder also played for San Francisco, Sacramento and Oakland in a professional career that ran from 1940 through 1957. Brovia—originally from Davenport, California—did reach the majors with the Cincinnati Reds in 1955; he also spent the 1943 through 1945 seasons in the military. In his four seasons with the Beavers, Brovia batted .295 with 103 home runs and 383 runs batted in. In 1947, batting against Seattle pitcher Sig Jakucki, Brovia crushed a 560-foot-plus home run over the 40-foot high centerfield fence in Seals Stadium, considered one of the longest homers in PCL history. Brovia's trade from San Francisco to Portland was for a most venal reason. Anticipating the style of players in later years, Brovia liked to wear his baseball pants down to his shoetops; Seals general manager Paul Fagan ordered the pants worn higher, Brovia wouldn't comply, and Fagan shipped him to the Beavers. (Courtesy of the Eskenazi Collection.)

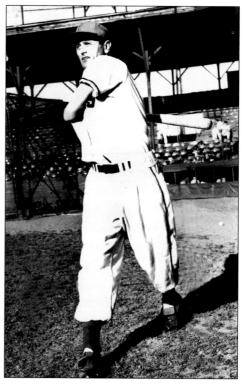

Eddie Basinski, one of the most popular players in Beavers history, laces up his spikes during Portland's 1952 training camp in Riverside, California. Basinski, a second baseman for the Beavers from 1947 through 1956, was an accomplished violinist known as "The Fiddler"; he'd played with his hometown Buffalo Symphony in 1944 and '45. Basinski, also known as "Professor," earned a bachelor's degree in music from the University of Buffalo. Basinski's first Portland manager, Jim Turner, called him "an escaped divinity student," Basinski told Dick Dobbins in his PCL history *The Grand Minor League*. World War II gave Basinski the chance to start his professional career at the top—with the Brooklyn Dodgers. Basinski, who had never played high school or college baseball, was playing in the Buffalo city leagues when he drew the attention from major league clubs and the Dodgers signed him early in 1944. Basinski played briefly with the Dodgers, tripling home the winning run in his first game; he was then sent to Montreal of the International League for the rest of the season. He played for the Dodgers in 1945 and made the National League All-Star team. Basinski also saw action with the Pittsburgh Pirates in 1947; his major league career consisted of 203 games with a .244 batting average, 4 homers and 59 RBIs. When he landed in Portland later that season, Basinski had found his baseball home. He played 1,460 games—including a team-record 558 in a row at one point—in his 10 seasons with the Beavers, batting .258 with 89 homers and driving in 771 runs. Basinski was voted by fans onto the Beavers' all-time team in 1953. (Oregon Historical Society CN 021169.)

The final home run by a Beaver at Vaughn Street was hit by Eddie Basinski on the final day of the ballpark's life. In the fifth inning of the first game of a season-ending doubleheader, Basinski homered off Oakland's Carl Drews; waiting for Basinski at home plate are Luis Marquez (No. 8), Dick Whitman (No. 3), Frankie Austin and batboy Bill McCallen. The Beavers won that game 6-5, then took the finale 5-2. (Courtesy of the Ranta Collection.)

The Beavers' clubhouse boys during the 1949 season included (left to right) Stan Bozich, Tom Becic, Ron Bottler and Bill Bottler. The Bottler brothers attended Roosevelt High and Oregon and played together for the Beavers as backups in 1952 and '55. Bill Bottler also pitched for the Beavers in 1954, and Ron also caught for the Beavers in 1953, '56 and '57. Neither made it to the major leagues. Bill's best mark for the Beavers was a 1-0 record and 3.33 earned run average in 1954; Ron's was batting .227 with three home runs and 20 home runs in 1956. (Courtesy of the Larrance Collection.)

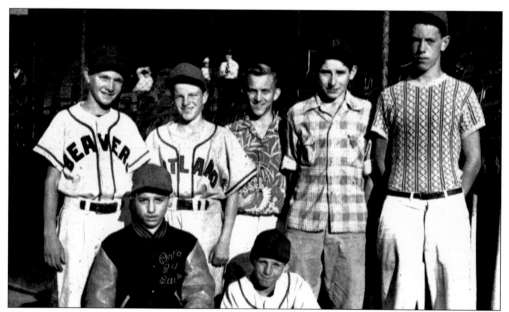

When the Beavers selected their batboys and ballboys for 1951, they didn't keep it all in the family but they kept a lot of it in the family. Kneeling are Dick Benevento (left), son of Beavers' groundskeeper Rocky Benevento, and Timmy Berg (right), son of team trainer Tip Berg. (Courtesy of the Larrance Collection.)

In an effort to beat the summer heat, the Hollywood Stars experimented with shorts as the lower part of their uniforms in 1950 and '51. Here, Portland manager Bill Sweeney (left) presents Hollywood manager Fred Haney—who had come up with the shorts idea—with a bouquet at the lineup exchange prior to a game in 1950. Bill Fleming, a pitcher for the Beavers, told Dick Dobbins in *The Grand Minor League:* "We used to kid them a lot . . . Bill Sweeney came out to the umpires with the lineup card wearing a dress, and we all waved hankies at them." (Oregon Historical Society neg. ORHI 58409.)

A picture inside the Vaughn Street press box about 1950 shows (left to right) Lenny Anderson, Seattle Times; Jim Cour, Associated Press; Dan Dwyer, Western Union telegrapher; Marlowe Branagan, Oregon Journal, and Larry Shaw, press box attendant. In the ballpark's later years, the press box was located at field level directly behind home plate, much as it was at Multnomah/Civic Stadium from 1969 through 1993. (Courtesy of the Larrance Collection.)

Legend has it that Rocky Benevento and his grounds crew spent a lot of time putting out fires in the wooden grandstand and bleachers at Vaughn Street. It's possible that some of those small blazes were caused by fans who had picked up their matches during a stop at the nearby Base Ball Tavern on the way to the game, or at broadcaster Rollie Truitt's smoke shop in a downtown hotel. The Beavers also put their own logo on matchbooks in the late 1940s. (Courtesy of the Christiansen Collection, the Larrance Collection.)

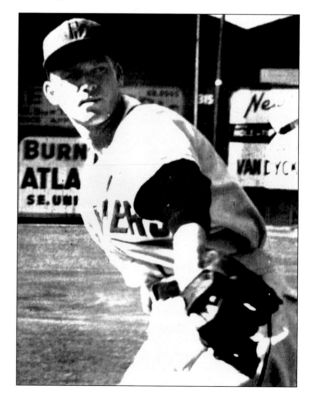

Red Adams was a career Pacific Coast Leaguer and spent 1950 through 1956 in Portland. That was part of his 15 seasons in the PCL, pitching parts of nine seasons for Los Angeles and also for San Diego and Sacramento. He had a brief major league fling with the Chicago Cubs in 1946, going 0-1 with an 8.45 earned run average. Adams was traded to Los Angeles during the 1956 season, in time to help one of the greatest PCL teams ever to the pennant with a 107-61 record. In the years he pitched for the Beavers, Adams was 69-72 with a 3.56 ERA. Adams led the PCL in ERA in 1952 with a 2.17 mark and threw four shutouts, but his record was 15-16. He was a hard-luck pitcher again in 1955, when he lowered his ERA to 2.05 but was just 12-12 record. (Courtesy of the Larrance Collection.)

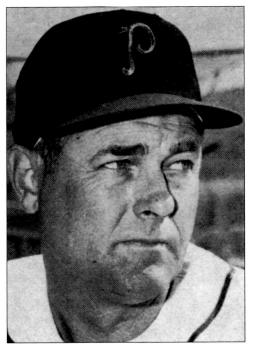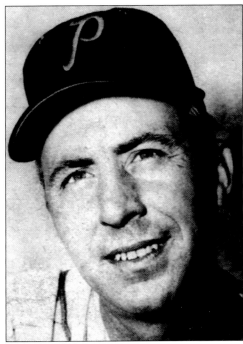

(*above, left*) Bill Fleming pitched for the Boston Red Sox in 1940 and '41 and for the Chicago Cubs from 1942 through 1946, except for a time out for the war effort in 1945. He returned from World War II in 1946 but only lasted part of the season in Chicago, ending his major league career with a 16-21 record and 3.79 earned run average. He was sent to Los Angeles of the Pacific Coast League in the middle of 1946; his uncle, David Fleming, had been that team's president. Fleming went to Portland in the middle of the 1948 season and remained with the Beavers for the remainder of his career, finishing with the 1953 season. The last three of those seasons he was also the pitching coach and saw limited action. During the 1948-50 seasons when he pitched full-time for the Beavers, he had a 21-15 record and 4.06 earned run average. (Courtesy of the Larrance Collection.)

(*above, right*) Royce Lint, born on New Years Day, 1921, came to the Beavers in the middle of the 1952 season. He had a career year with Portland in 1953, going 22-10 with a 3.10 earned run average and was selected to the Pacific Coast League all-star team. Based on his strong showing for the Beavers, Lint went to the St. Louis Cardinals in 1954 where he posted a 2-3 mark as a 33-year-old rookie. It was his only duty in the major leagues. Lint returned to the Beavers, going 9-11 in 1955 before finishing his career with a 4-9 record for the 1956 Beavers. (Courtesy of the Larrance Collection.)

Close Shave at the Plate

(*above*) Barber Leonard Graven (left) shaves Beaver broadcaster Bob Blackburn (center) at home plate at Vaughn Street on July 3, 1953, with Rollie Truitt (right) at the microphone describing the action. Earlier in the season, Blackburn and Truitt had vowed to go unshaven until the Beavers got out of the cellar. It took nearly a month, but the Beavers bounced back to finish fourth with a 92-88 record. When Truitt got into the barber's chair moments later, groundskeeper Rocky Benevento offered to help with a pair of pruning shears but his aid was declined. Blackburn came to the Beavers in 1950 at age 25 to assist Truitt in the broadcast booth, leaving a job as sports director at a Fresno, California, radio station. Once in Oregon, Blackburn also became the broadcaster for Oregon State football and basketball. He remained broadcaster for the Beavers—both Portland and Oregon State—through 1967, when he was named radio voice of Seattle's new National Basketball Association franchise, the SuperSonics. (Courtesy of the Larrance Collection.)

(*left*) The last year Portland fans would be able to go to Vaughn Street to take in a game was 1955; it had already been announced that the Beavers would be moving into Multnomah Stadium the next season. Nearly 200,000 fans turned out in the ballpark's final season to watch a team that finished in fifth place with an 86-86 record. (Courtesy of the Larrance Collection.)

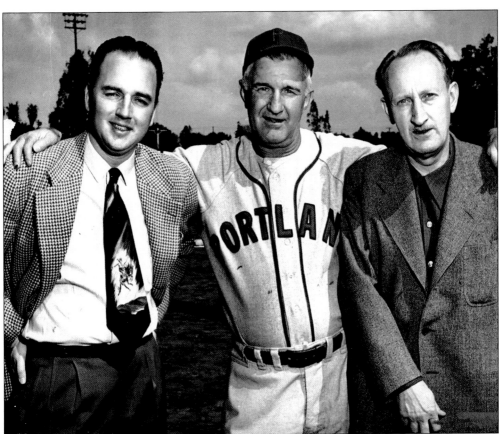

Clay Hopper (center) chats with broadcasters Bob Blackburn (left) and Rollie Truitt (right). Hopper, the Beavers' manager from 1952-55, was a native Mississippian and a cotton merchant in the offseason. In 1946, he was named Minor League Manager of the Year by *The Sporting News* for taking the Montreal Royals to the International League pennant and the championship of the Junior World Series. That Montreal team featured a pitcher named Tommy Lasorda and a promising infielder named Jackie Robinson, who was integrating "organized" baseball that season. In Hopper's first season in Portland in 1952, he was named Pacific Coast League Manager of the Year, guiding the Beavers to a 92-88 record and fourth place. Hopper spent four years in Portland, leading the team to a pair of fourth-place finishes, eighth place and finally fifth place in the Beavers' last season at Vaughn Street in 1955. Bill Fleming pitched and coached for Hopper in Portland, including running the club during spring training in 1953 while Hopper recovered from surgery for colon cancer. He told Dick Dobbins in *The Grand Minor League:* "He was a fine man and a good leader. We had competitive teams under him … I remember he was a good manager. That's why Branch Rickey picked him (to manage Robinson's first season)." (Courtesy of the Eskenazi Collection.)

(*above, left*) In Artie Wilson's first season in the Pacific Coast League—playing for San Diego and Oakland in 1949—he won the loop's batting crown with a .348 average, becoming the first player since 1917 to win the title without hitting a home run. Wilson played in 19 games for the New York Giants in 1951 and batted .182, but the native of Springfield, Alabama, was sent down to make room for a promising outfield prospect by the name of Willie Mays. Wilson played for Portland in 1955, batting .307 with two homers and 23 runs batted in, then split the 1956 season between the Beavers and Seattle with a .293 batting average and 25 RBIs. By 1962, Wilson had retired from baseball and was selling cars in Portland. That season, Beaver second baseman Milt Graff broke his leg and the club asked Wilson to return; he finished the season for them at age 41. (Courtesy of the Larrance Collection.)

(*above, right*) Rene Valdez, a Brooklyn Dodger farmhand, posted a 22-11 mark with a 3.43 earned run average for Portland in 1956 and was named to the Pacific Coast League all-star team. That effort earned him a brief callup to Brooklyn in 1957, where he put up a 1-1 mark in 13 innings pitched. Valdez finished his baseball career back in the PCL with Spokane in 1961. (Courtesy of the Larrance Collection.)

FREE! Baseball Suit

With the Purchase of $10 Admission Scrip

These coupons can be exchanged for any priced admission from bleachers to box seats, adults or children.

Portland Baseball Club
N.W. 24th and Vaughn—Portland, Oregon

Enclosed find $_____ (check) (cash) for admission scrip to Portland Beaver 1955 home games. Send me boy's baseball suit (s). (Circle age for size—(4, 6, 8, 10, 12, 14).

Name _____

Address _____

City _____

MAIL COUPON TODAY! OR BRING TO TICKET OFFICE

The script is good for any of the Portland Beaver 1955 home games. Here's a chance to support Portland's home-owned Beavers, see top-notch professional baseball and get a Bonus of a free boy's baseball suit — all for only ten dollars. Scrip

In their final season at Vaughn Street, the Beavers were willing to give Portland's kids the shirts off their back—almost. Fans could get a junior baseball uniform if they spent $10 on "admission scrip." The scrip could be exchanged for seats of any price at the ballpark, be they the $2 box seats, the $1.65 reserved grandstand seats, grandstand general admission seats of $1.25 for adults, 80 cents for students, 50 cents for children under age 12, or bleacher seats of 80 cents for adults, 50 cents for students and 25 cents for children. (Courtesy of the Larrance Collection.)

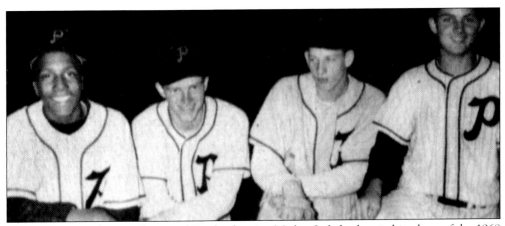

Three-time major league all-star and Portland native Mickey Lolich, the pitching hero of the 1968 World Series, did double duty for the Beavers. He was first a batboy in 1955, where he was identified in the team annual as Mickey Lolidge; he's third from left in this photo with (left to right) Vern Brazzle, Pat Tabor and Bill McCallen. Lolich began his minor league career in 1959, and by 1962 he returned to Portland to pitch for the Beavers and he posted a 10-9 record. That earned him a promotion to the Detroit Tigers for the 1963 season, where he proceeded to win 217 games over the next 17 years, all but 10 of those for the Tigers. Lolich dominated the 1968 World Series, allowing the St. Louis Cardinals just five runs in three complete-game wins, including the Game Seven finale in which he bested Bob Gibson on two days' rest. Lolich also hit his only career home run in Game Two of that World Series. (Courtesy of the Larrance Collection.)

Bill Garbarino joined the Beavers in 1944 as office manager and became assistant general manager in 1949; he retired following the 1954 season. A native Portlander, Garbarino was known as "Mister Baseball" for his involvement in the game as a semipro player and umpire and American Legion manager. Garbarino coached a pair of American Legion state champs in Oregon—the 1929 Gyro Cardinals and the 1931 East Side Commercial Club. (Courtesy of the Eskenazi Collection.)

The mid-1950s, stopping by the ballpark for a game could be just the start of an evening's entertainment. The Baseball Inn, located across Vaughn Street from the ballpark, offered live music and dancing six nights a week. After the Beavers moved to Multnomah Stadium for the 1956 season, The Dugout was a quick walk away from the seats on the third base side of the ballpark. (Courtesy of the Larrance Collection.)

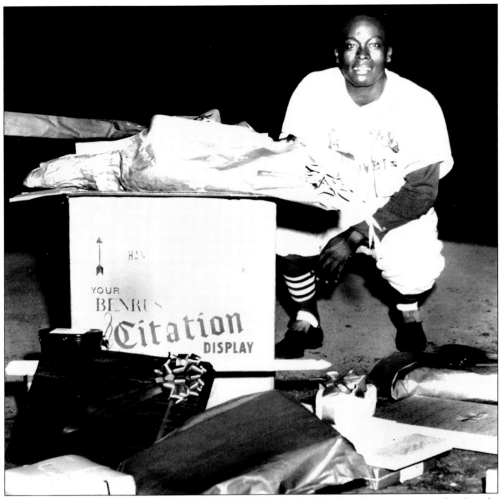

Luis Marquez, a Puerto Rican outfielder, was reputed to be the fastest man in the Pacific Coast League early in his career with the Beavers; he's shown here on Luis Marquez Night at Multnomah Stadium. He played in Portland in 1949 and '50, then again from 1955 through 1958, batting .303 with 85 home runs and 426 runs batted in. Marquez's top seasons were in 1956, when he batted .344 with 25 homers and 110 RBIs, and 1957, when he batted .277 with 31 homers and 85 RBIs. "We were playing against him and I remember, immediately, you don't like him," pitcher Red Adams told Dick Dobbins in *The Grand Minor League*. "But then I got on the club with him, and some of those things that were irritating are assets now. Not only that, he was a funny guy." Portland infielder Eddie Basinski recalled how Marquez came out for a game one day and pointed to his face; where white players put eye black, Marquez had strips of white under his eyes. Marquez reached the major leagues with the Boston Braves in 1951 and again with the Chicago Cubs and Pittsburgh Pirates in 1954. In 99 games, he hit .182 with five doubles, one triple and 11 RBIs. He suffered a leg injury while with the Braves, though; where he'd stolen 32 and 38 bases in his first two seasons with Portland, he never stole more than 18 in a season during his second stay. Prior to that, his reputation earned him footrace challenges from opposing players. Marquez had played in the Negro Leagues from 1945 through 1948 for the New York Black Yankees, Homestead Grays and Baltimore Elite Giants, including a 1946 season in which he batted .417. He and infielder Frankie Austin integrated the Beavers when they joined the team in 1949. (Courtesy of the Eskenazi Collection.)

Tommy Holmes (left) managed the Beavers for the first part of the 1956 season. Holmes hit in 37 straight games for the Boston Braves in 1945, a National League record until broken by Pete Rose in 1978. An outfielder, Holmes played in the big leagues from 1942 through 1952, all with the Braves until he spent the final year with the Brooklyn Dodgers. He was a National League All-Star in 1945 and '48. Holmes' stellar year was 1945, as he finished second to Phil Cavarretta in the Most Valuable Player voting; Holmes led the league in hits (224), slugging percentage (577), doubles (47), total bases (367), and home runs (28). He narrowly missed the Triple Crown, finishing second in batting average (.352) and runs batted in (117). (Courtesy of the Ranta Collection.)

Six

24th and Vaughn, 20th and Morrison

In their first century, the Portland Beavers moved out of the city three times. During that same span, they moved within the city just once—approximately 24 blocks from one Northwest Portland address to another, the shift coming between the 1955 and 1956 seasons.

From their founding in 1903 through 1955, the Beavers played at Vaughn Street, whose main gate was located on the northwest corner of the intersection of N.W. 24th Avenue and N.W. Vaughn Street. Since the start of 1956, the various versions of the Beavers have played at what is now known as PGE Park, whose main gate is located at the southwest corner of N.W. 20th Avenue and N.W. Morrison Street.

Vaughn Street actually predated the city's Pacific Coast League franchise, having opened in 1901 to house the Portland Webfoots of the Pacific Northwest League. Two rival streetcar lines—the Portland Railway Company and the City & Suburban Lines—joined forces to build the ballpark. They figured that the ballgames would increase ridership on both their lines, and they were right.

Initially, the stadium included just a small grandstand behind home plate that held approximately 3,000 fans. Only half of those were filled for the park's opener in May 1901, as the Webfoots beat Spokane 8-6. The capacity was still 3,000 in 1903, when Portland joined the Pacific Coast League.

The grandstand doubled in size in time for the 1905 Lewis & Clark Exposition, when a 440-yard running track was built on the lot for the National Track and Field Games. During those events, the Beavers played some games at Multnomah Field—now the site of PGE Park.

At the end of the 1911 season, Portland had won three pennants in six seasons. The team's financial situation had solidified to the point that the team's owners, Walter McCredie and Judge W.W. McCredie, wanted to emphasize the team's success in a tangible way, and that turned out to be their ballpark.

The facility was completely rebuilt into the configuration that became familiar to generations of Portland baseball fans. It included a covered grandstand that extended from just past first base around home plate nearly to the leftfield foul pole; it had eight rows of box seats below an aisleway, then another 13 rows of individual seats behind that. There was a large bleacher between the end of the grandstand and the rightfield foul pole that rose from 23 rows at the homeplate side to 36 rows; another bleacher was behind a tall leftfield wall, nine rows from leftfield to centerfield, then gradually rising to 31 rows in dead centerfield with the scoreboard above that.

Vaughn Street was considered one of the finest minor league ballparks in the country, if not the finest. When Judge W.W. McCredie died in 1935, one obituary recalled the opening of the new grandstand by calling it "the sensation of baseball, because it inaugurated a minor

league precedent of providing individual grandstand seats, which fellow magnates called an extravagance and a dangerous innovation."

As was the case at most ballparks of the era, the seats were located close to diamond. Eddie Basinski, a Portland infielder from 1947 through 1956, told Dick Dobbins in The *Grand Minor League:* "That park had great tradition. Many great players came through that ballpark. And the people loved it. They were so close to the field they could hear the arguments and the swearing. They could even hear the spitting."

Vaughn Street was a small park in other ways, as well. Rightfield? Try 315 feet to a tall wall that separated the field from the Oregon Electric Steel foundry. It was 331 feet to the leftfield fence and a mere 368 to centerfield.

The foundry provided a chunk of the park's character and the smoke it belched could be a challenge to players and fans alike, dimming the lights during night games (night baseball arrived in 1930), and—when the wind was right (or maybe wrong)—it could send the customers home dappled with soot.

During the wooden ballpark's later years, groundskeeper Rocky Benevento often spent much of games running about beneath the stands extinguishing fires caused by fans' discarded cigars and cigarettes. Writing for *Baseball Digest* in 1954, Bill Conlin said the Beavers were content to "fight a continuing battle with a city zoning commission which persistently condemns the rattletrap Portland ballpark. Just as regularly as the park is condemned, which is every year, the Beavers go to the politicians and ask for another year's usage of the property, with promises that they will build a new park."

Indeed, the Beavers had hoped to build a new ballpark since the late 1940s and even went so far as to obtain land in Southeast Portland, but the plan never came to fruition. In the meantime, Vaughn Street continued to age.

"I remember one time when people started stomping for a rally, and I looked at the light poles," Basinski told Dobbins. "They were waving around like there was an earthquake. I told Frankie (Austin), 'You know, one day the whole place is going to go down like dominoes."

A section of the left-centerfield bleachers burned during the late 1940s and the solid wooden seats were replaced with less-structured scaffold-style seats, as were the bleachers down the rightfield line. The modifications slightly reduced the ballpark's capacity down closer to 10,000 seats.

In 1955, the Beavers became a publicly-held entity with fans able to buy shares of the ballclub. Not long after, it was announced that negotiations had concluded that would allow the team to move from Vaughn Street to Multnomah Stadium for the 1956 season. The old ballpark hosted its final games on Sept. 11, 1955 with the Beavers sweeping a doubleheader from the Oakland Oaks by scores of 6-5 and 5-2.

In his retrospective "We Remember Vaughn Street" late in the summer of 1955, sports editor L.H. Gregory of *The Oregonian* noted, "With the Portland baseball club's departure from Vaughn Street, more than just an era comes to a close—a way of life is ending. Vaughn Street grew in the simple days when wood stands were good enough; it gives way to a complex era of steel and concrete, of formality in design and in living. The old park has had its day."

There had been talk of moving the Beavers into Multnomah Stadium since 1927, but nothing ever came of it. Turning the facility into a ballpark would take some work. The site had been used for athletic events since the 1890s, but it had been primarily a venue for football and a variety of races—mainly track and field and greyhounds.

Home plate could be tucked into the curve of the J-shaped grandstand that had been built in 1926. Providing enough room for leftfield and centerfield, though, meant a large excavation project on the east side of the stadium where uncovered football seats had been located.

Work began in December, 1955. A March snowstorm didn't help as workers hurried to complete the renovation in time for a late-April opener. In addition to digging back almost to N.W. 18th Street to allow for the field, bleachers had to be erected in leftfield and centerfield; eight rows of box seats were constructed between the front row of the grandstand and the infield, with dugouts and a press area underneath.

Through it all, Benevento worked at transplanting the turf from Vaughn Street onto the new ballfield at Multnomah Stadium.

Where Vaughn Street had a short rightfield line with a high fence in front of the foundry, Multnomah Stadium was just the opposite—even with the excavation toward N.W. 18th Street, the leftfield line could only extend to about 310 feet. Rightfield was a long poke of about 345 feet toward the Multnomah Athletic Club building.

And while the rows of new box seats brought a few fans close to the field, the old grandstand's 19 rows below the aisle and 27 rows above it lent a cavernous feeling that was far different than the cozy feeling fans had known at Vaughn Street.

"As far as the fans were concerned, moving into Multnomah Stadium was a big mistake," Basinski told Dobbins. "The stadium used to be a big track and a football stadium, and it separated the players from the fans. The distance was too great."

For the next dozen years, the ballpark remained largely the same. The Multnomah Athletic Club sold the stadium to the City of Portland for $2.1 million in 1967, and it was renamed Civic Stadium.

Hoping to attract more events, the city installed artificial turf prior to the 1969 season. The switch to Tartan Turf—an effort led by City Commissioner Frank Ivancie—gave Portland the nation's first outdoor multi-purpose stadium with artificial turf.

Installing the turf led to the elimination of the boxes between the old grandstand and the diamond, further distancing the fans from the players. Wet weather delayed laying down the turf, and the home opener was pushed back two weeks to April 24. Even then, not all the turf was in place and rightfield and centerfield were only the turf's base, resembling an asphalt tennis court. Also, the entire field was artificial turf, even the areas immediately around the bases. "Sliding spheres," described in *The Sporting News* as being like "large grains of sand," were scattered around the bases to provide a sliding surface for base runners. That experiment lasted only until late June, when the Tartan Turf was removed around the bases and dirt sliding pits were put into place.

Coincidentally, within a few weeks of the date that the Beavers played their first home game on something other than grass and dirt, Benevento—long the caretaker of those elements in Portland—died at age 71.

Attendance continued to decline and the Beavers moved to Spokane after the 1972 season. When Portland was granted an expansion franchise in the PCL to begin play in 1978, it moved back into the same old facility it had left.

But, in time for the 1982 season, the stadium had its first significant renovation since the Beavers had moved in in 1956. A new roof and football press box were constructed, almost 7,300 plastic theater-style seats replaced the wooden benches below the aisleway, an electronic scoreboard rose above left-centerfield, 666 box seats and new dugouts were rebuilt at field level, locker rooms were improved, and the concourse was spruced up at a cost of $9.5 million. But the Beavers left town again after the 1993 season, and owner Joe Buzas cited the stadium as one reason.

"I loved Portland. Still do," he told the Portland Business Journal in 1999. "The fans and community were great. But with that stadium, it was tough. It's not a baseball park. People just didn't like it enough to keep coming back."

Part of luring the Pacific Coast League back to Portland for a third try in 2001 was the transformation of Civic Stadium into PGE Park. The $38.5 million project eliminated the bleachers in leftfield and centerfield, constructed four rows of skyboxes above the aisle behind home plate, added private suites at field level, lowered and widened the main concourse, put new seats below the aisle and painted the old benches above the aisle a matching "baseball green." The work also added amenities like a soda fountain, shoeshine stand, organ and gargantuan hand-operated scoreboard to give the ballpark an old-time feel.

It worked.

"Coming up with the (Chicago) Cubs, I love the old ballparks, and what I've noticed about this one is how loud it gets," Beavers catcher Rick Wilkins told the San Diego *Union Tribune* in 2001. "A crowd of 5,000 here sounds like 15,000."

An early look at Vaughn Street; the best guess at when this undated photo was taken would be prior to the 1912 rebuilding of the ballpark, since there are no bleachers in left or center fields. Note the single umpire stationed behind the pitcher. (Courtesy of the Larrance Collection.)

Night baseball came to Vaughn Street in 1930. With the seats and field empty, it could be that this was taken during a test of the lights to determine how the field would look during play after dark. Note the old centerfield bleachers whose shape followed the lines of the ballpark's edge. (Oregon Historical Society neg. OJ 0371N6096.)

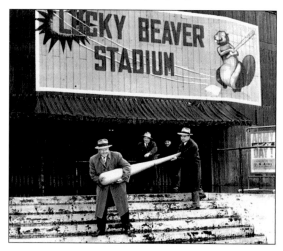

Here's the home plate entrance to Vaughn Street; Beaver fan Chuck Christensen believes that when he was a youngster, the large bat hung over the beer bar inside the ballpark. The two men carrying off the oversized club are not identified, but the two behind them appear to be owner George Norgan (left) and groundskeeper Rocky Benevento (right). Note the "Lucky Beavers Stadium" sign; that name was often used in the ballclub's literature but it never seemed to catch on with the public or the press, who generally referred to the ballpark as Vaughn Street. (Courtesy of the Christiansen Collection.)

In 1946, Portland's program noted that due to the efforts of team president George Norgan and the team's other executives, "The management has in mind the construction of a modern plant as soon as a site and material are made available." World War II had just ended, and at that point construction centered on housing for returning veterans. By 1948, the concept of a new ballpark had advanced as far as this drawing. There were a number of references to the planned ballpark as "Norgan Stadium," and one story said the Beavers had purchased a site at 82nd and Holgate. The onset of the Korean War scuttled those plans, and the Beavers remained at Vaughn Street until the move to Multnomah Stadium for the 1956 season. (Courtesy of the Larrance Collection.)

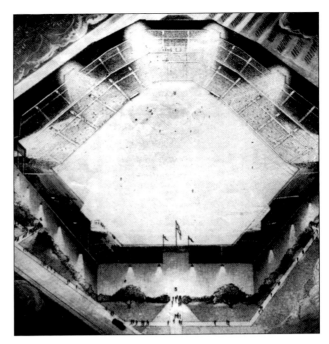

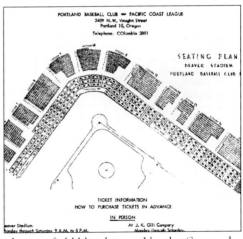

(*above, left*) This was the second set of leftfield and centerfield bleachers at Vaughn Street; the original bleachers were partially destroyed by a fire at the adjoining foundry in the late 1940s. The new seats left a gap in left-centerfield; brought the front row in leftfield down to field level; eliminated the solid, sign-bearing leftfield wall in favor of a chain-link fence; and turned the centerfield bleachers into a rectangular section as opposed to the old seats whose edges rose at an angle along the edges of the ballpark (for comparison, see the 1930 photo looking out from behind home plate). (Oregon Historical Society ORHI 55 372.)

(*above, right*) If you were looking for a good seat at Vaughn Street, here were your choices; this diagram from the 1955 Rollie Truitt Scrapbook cuts off the leftfield corner of the main grandstand. For adults, box seats were $2, reserved seats $1.65, general admission $1.25 and the not-shown bleachers 80 cents. (Courtesy of the Larrance Collection.)

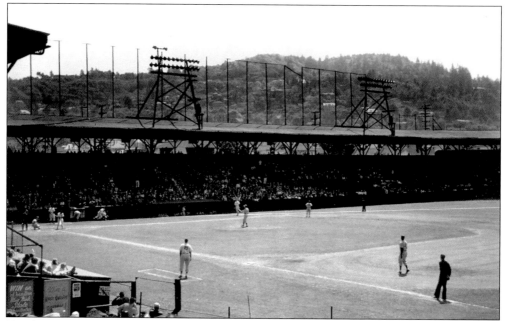

Vaughn Street's main grandstand during a game in the early 1950s, as seen from the rightfield bleachers. Just about the only way to guarantee not having a pole at least partially obstructing you view was to purchase one of the box seats, which gave you a folding chair in the first eight rows. (Courtesy of the Kirk Collection.)

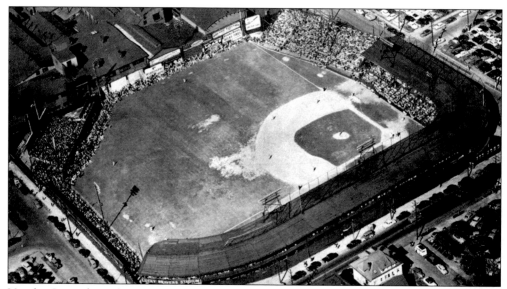

Vaughn Street from above, late in its heyday. It's Opening Day, 1951, and the Beavers are in the process of pulling in 23,568 for a day-night doubleheader. Here, on a beautiful spring afternoon, a crowd of 13,088 sees Portland lose to San Diego 8-4, after the Beavers had taken a one-run lead into the ninth inning. That evening, another 10,480 would watch as Red Adams tossed a complete-game 5-2 victory. Adams was in and out of trouble all night, giving up eight hits and nine walks as the Beavers won to retain their spot atop the Pacific Coast League standings. (Courtesy of the Ranta Collection.)

The *Oregon Journal* gave Vaughn Street an artistic farewell in its edition of Sept. 11, 1955. The Beavers closed the ballpark later that day by sweeping the Oakland Oaks 6-5 and 5-2 in front of 4,162 fans. *Oregon Journal* sportswriter Marlowe Branagan wrote: "Old Vaughn Street, the scene of deeds and misdeeds for 54 years in organized baseball in Portland, was given back to the ages—in official fashion—Sunday, but a final chapter of achievement in the ancient ruins was a glittering one." The wins left the Beavers with an 86-86 record and fifth-place finish. (Courtesy of the Carlson Collection.)

Quoth the Termites—Today and Never More

IN MEMORY

1901-1955

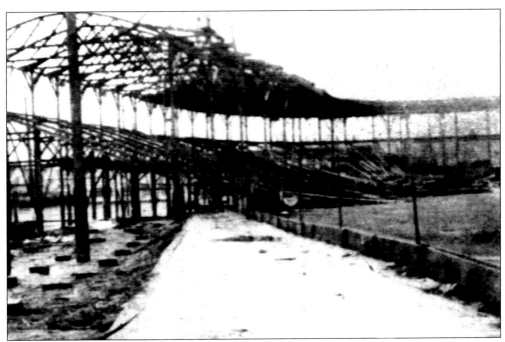

Vaughn Street had been flirting with condemnation for several years prior to the Beavers' move to Multnomah Stadium. Once the team left, the ballpark didn't last long; demolition began prior to the start of the 1956 season. Looking in from the rightfield corner, only the skeleton of the grandstand remains. (Courtesy of the Ranta Collection.)

The Beavers' new home was featured on the cover of the 1956 *Rollie Truitt Scrapbook*. Note the bleachers sketched into centerfield and rightfield, since a photograph with the actual construction completed was not available. (Courtesy of the Ranta Collection.)

With the 1956 season approaching, *The Sunday Oregonian's Northwest Magazine* provided fans with an overview of how Multnomah Stadium had been adapted for the Beavers' use as a ballpark. The accompanying article speculated that "If the fans like the Beavers 'new' look, it is conceivable that Portland could set a new minor league attendance record for a single season, surpassing the 678,000 figure recorded several years ago in San Francisco. At any rate, they'll have the stadium in which to do it." The actual number that Portland drew in 1956 was 305,729, up from the previous season's 199,238; the Beavers wouldn't again break the 300,000 mark until 2001. (Courtesy of theRanta Collection.)

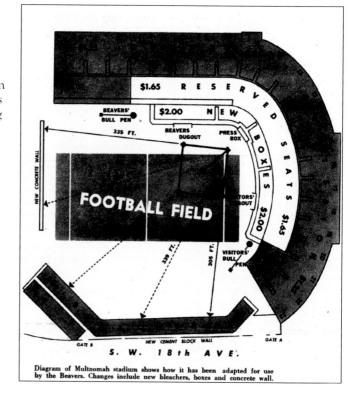

Diagram of Multnomah stadium shows how it has been adapted for use by the Beavers. Changes include new bleachers, boxes and concrete wall.

When the Beavers moved from Vaughn Street to Multnomah Stadium, the surroundings might have been different but the field was the same—the ballclub moved the playing surface from the old ballpark to the new. Here, it's late March 1956 and longtime groundskeeper Rocky Benevento is installing the turf at Multnomah Stadium. (Oregon Historical Society neg. ORHI 085243.)

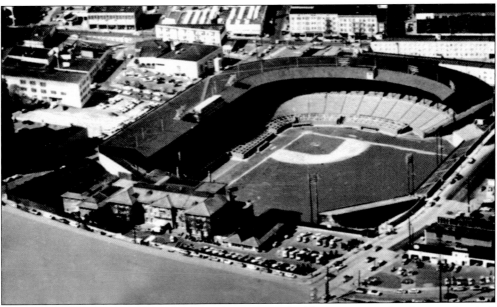

Here is an aerial view of Multnomah Stadium after it had been renovated to house a baseball diamond for the Beavers. The old, ornate Multnomah Athletic Club building is still the ballpark's neighbor beyond the rightfield fence. (Courtesy of the Eskenazi Collection.)

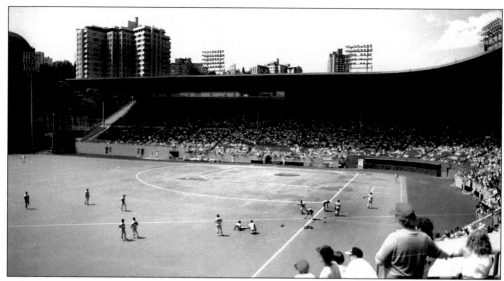

A look at Civic Stadium near the end of the Beavers' third stay in the city; it's the summer of 1991, and a large crowd is filing in to watch former Major League sensation Fernando Valenzuela pitch against the Beavers during a rehabilitation stint with the Edmonton Trappers. (Courtesy of the Carlson Collection.)

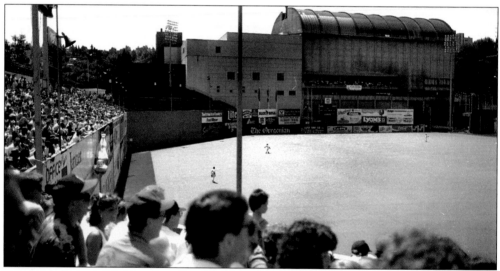

For decades, the leftfield wall at Civic Stadium was home to "the Jantzen lady"—a fiberglass model of the swimsuited woman that served as logo for the Jantzen sportswear company. The ground rules for balls bouncing off her? Randy Knuths, a Pacific Coast League umpire in the 1980s, said a ball bouncing off her and remaining in play was live; a ball bouncing off her and into the seats was a double; a ball lodging on her back or between her and the wall meant the umpires ruled how far a runner would likely have advanced (nearly always two bases); and a ball bouncing off her and then being interfered with by a fan also meant the umpires ruled how far a runner would have advanced. It wasn't just baseballs that might glance off the Jantzen lady. Knuths was working one night when a fan reaching over the wall for a baseball slipped over the edge, bounced off the Jantzen lady and went into a somersault, suffering a broken leg when he hit the warning track. (Courtesy of the Carlson Collection.)

Civic Stadium became PGE Park during a $38-million renovation during the winter of 2000-01. Here, looking into the ballpark from N.W. 18th Street late in the fall of 2000, the old concrete grandstand's section behind home plate has been removed to make way for four levels of private boxes. (Courtesy of the Andresen Collection.)

It's 2001, and PGE Park is now open as the upgraded, old-fashioned home of the Portland Beavers. When the renovation into PGE Park was complete, the main entrances to the ballpark included these large metal sculptures that seemed something between a human face and a catcher's mask. (Courtesy of the Portland Beavers.)

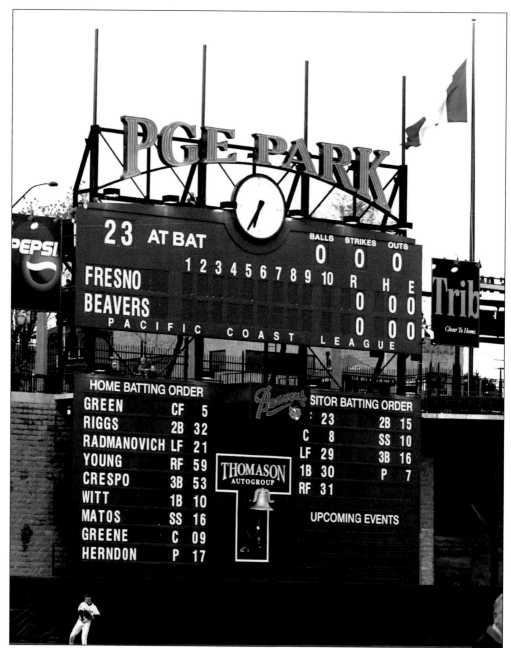

One of the features added when Civic Stadium was turned into PGE Park for the 2001 season was the hand-operated scoreboard in left-centerfield, 60 feet wide and nearly seven stories tall. The board includes complete lineups for both teams and takes a staff of four to operate; depending on the Beavers' most recent result, flags with a "W" or "L" were flown from the top of the structure. For the 2001 home opener, the operators included 71-year-olds Preston Holt, John Holt and Dick Montgomery; all three had the same jobs as 12-year-olds in 1942 at Vaughn Street. Montgomery, recalling the workings of the old centerfield scoreboard at Vaughn Street, told The Oregonian, "You'd turn an iron handle. Those scrolls were crinkly and creaky. It was an ancient system." (Courtesy of the Portland Beavers.)

SEVEN

1958–1972
No Longer the Only Game in Town

The world changed in 1958—at least as far as the Portland Beavers were concerned.

Major League Baseball reached the West Coast when the Brooklyn Dodgers moved to Los Angeles and the New York Giants moved to San Francisco. After more than half a century as king of the hill, the Pacific Coast League found itself no longer the highest level of baseball available in nearly half the country. The league reverted from the "Open" classification back to Triple-A.

Portland had been accustomed to playing among the metropolises of the Pacific—Los Angeles, San Francisco, Hollywood. Those cities were now replaced by Phoenix, Salt Lake City and Spokane; expansions of the PCL in the mid-1960s brought in such far-flung opponents as Oklahoma City, Dallas-Forth Worth, Indianapolis and Arkansas.

Not only were the longtime rivalries gone, but so was the sense of Portland controlling its own baseball destiny.

Portland had been a part of loose agreements with a number of teams over the years, dating back to the arrangement with the Cleveland Indians during Walter McCredie's heyday. The Philadelphia Athletics had also played a big role in the Beavers' success in the 1930s, but the Portland ballclub had largely been responsible—for good or ill—for procuring its own players.

That changed in 1961, when the Beavers became a full-fledged member of a farm system for the first time; it was the St. Louis Cardinals supplying the players that season. The arrangement lasted only one year, though, and Portland's next parent club didn't have quite the baseball acumen of the Cards.

No, what Portland got for the next two seasons were the Triple-A players of the Kansas City Athletics. Given that the A's were generally considered pretty much a Triple-A team themselves, it's a tribute to the Beavers' efforts that they were able to finish above the cellar in both 1962 and '63.

The Oregonian went as far as to publish an editorial in the spring of 1963 calling on Kansas City to send the Beavers a more capable ballclub to represent the city. Attendance in those years dropped under 100,000 for the first time since 1940, but that phenomenon wasn't unique to Portland.

In *The Minor League Encyclopedia*, editors Lloyd Johnson and Miles Wolff call the seasons from 1963 through 1977 "The Subsistence Years," noting that the number of minor leagues fell as low as 15 during the mid-1960s. In Portland, baseball was also being challenged for fan interest by another professional sport, as hockey's Portland Buckaroos drew large crowds to the just-opened Memorial Coliseum.

Cleveland returned as Portland's parent club in 1964, and the Indians sent players who sparked a surge in baseball interest. Pitchers Luis Tiant and Sam McDowell headlined a 1964

team that finished just one game out in the West Division race, and attendance bounded from 87,438 to 207,848.

The next season, the Beavers won their first championship of any sort since the 1945 pennant-winners when manager John Lipon took them to the West Division title. The PCL title eluded Portland, though, when it lost to Oklahoma City in the championship series.

The Indians kept their ties with Portland for six seasons, but attendance continued to slide and the team went into debt. Multnomah Stadium became less fan-friendly in 1969, when the city installed artificial turf in the ballpark and the field-level box seats were removed in the process.

In the middle of the 1969 season, the board of directors put the franchise up for sale. It was bought by three businessmen, including Paul Ail of Portland.

In January 1970, a Major League working agreement with the Seattle Pilots was announced. The Pacific Northwest alliance didn't last long, though, as the Pilots became the Milwaukee Brewers just before the start of the season.

Bill Cutler took over ownership of the team and ran it largely as a family operation. The Beavers were in the Minnesota Twins' farm system in 1971, then back with the Indians in 1972.

Finances remained tight, but Cutler planned on returning to Portland in 1973 and leased what was now called Civic Stadium from the city. However, the city was booking a variety of events into the stadium and there was difficulty in making up the PCL schedule.

Cutler told *The Sporting News* that he'd given the city a deadline to work out the conflicts, but it passed without a resolution. In January, 1973, Cutler went to the PCL board of directors and proposed moving the franchise to Spokane; it was approved.

"It's a shame," Ed Honeyman, president of the minor league baseball writers association, told *The Sporting News*. "Portland was a central point on the circuit. It just won't be the same league next year without the Beavers."

Added Cutler: "Most of the owners felt all Portland needs is a rest. The kids here deserve a baseball team and I'm sure some day they'll have one again."

In 1959, the Beavers saluted Oregon's Centennial on the cover of their game programs. The ballclub didn't set off celebrations on the field, going 75-77 and finishing in sixth place. (Courtesy of the Larrance Collection.)

It's July, 1959 and Vancouver's Joe Durham is pulling into third base behind George Freese. The power-hitting Freese was the Beavers' third baseman from 1957 through 1960. He was a three-time Pacific Coast League all-star, earning that honor in 1956 for Los Angeles, and in 1958 and '59 with Portland. In 1958, Freese hit .305 with 31 home runs and 80 RBI, and then followed that up in 1959 by hitting .319 with 21 homers and 81 knocked in. He played parts of three seasons in the major leagues with Detroit (1953), Pittsburgh (1955), and the Chicago Cubs (1961). While he hit only three big league home runs, one of them was an inside-the-park grand slam. Freese was no one-dimensional athlete, earning All-America honorable mention honors at quarterback for West Virginia in 1946. George's younger brother Gene also played for several years in the PCL, and 11 years in the Major Leagues. Their paths crossed in 1955 when both played third base for the Pirates, and again the next year in the PCL, when George played for the Angels while Gene toiled for cross-town rival Hollywood. Freese spent a dozen years as a minor league manager, and made Portland his home after his Beaver days. (Oregon Historical Society neg. ORHI 66819.)

The Beavers didn't play their 1960 home opener until April 29 and when they did, Tacoma sidearmer Juan Marichal was waiting for them. Marichal, on his way to stardom with the San Francisco Giants, beat the Beavers 7-4 at Multnomah Stadium in the first portion of a day-night doubleheader. Despite appearances, the Portland hitter isn't bailing out; Beaver pitcher Noel Mickelsen, is starting to square for a sacrifice bunt. In the night game, Portland's Bob Anderton celebrated his 33rd birthday by throwing a four-hitter in a 1-0 win. The day game, on a sunny afternoon, drew just 5,551, prompting the *Oregon Journal's* George Pasero to observe, "a lot of grandmothers didn't die this week, judging from the crowd." Mickelsen led the Pacific Coast League in strikeouts in 1960, fanning 156 hitters, but went just 13-17 with a 4.80 earned run average in his only Portland season. Portland finished in last place with a 64-90 record, $28\frac{1}{2}$ games behind Spokane. Mickelsen, originally from Oto, Iowa, attended San Diego State before signing his first professional contract in 1956. (Oregon Historical Society neg. ORHI 098455.)

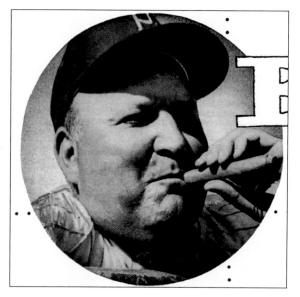

Tommy Heath managed the Beavers from 1958 through 1960, with Portland going 217-243. In his last two seasons, Heath had the misfortune to manage a team whose players were largely provided by the lowly Kansas City Athletics, including a group in 1960 that went 64-90 for a last-place finish. Prior to that, Heath had managed San Francisco from 1952 through 1955 and Sacramento in 1956 and '57. Heath, a long-time minor league catcher, played mostly in the minor leagues between 1932 and 1946; he was a backup catcher for the St Louis Browns in 1935, '37, and '38. (Courtesy of the Larrance Collection.)

Duane Pillette's second stint in Portland lasted from 1958 through 1960 and he went 17-13 in those seasons. Previously, he'd gone 4-2 for Portland in 1947 and 14-11 in 1948 as he added to his family's Pacific Coast League lineage. His father, Herman Polycarp "Old Folks" Pilette pitched for 23 years in the PCL between 1920 and 1945—at which point he was 49 years old. By the time he retired, "Old Folks" was the all-time PCL leader in games pitched, hits allowed, and runs allowed. Herman's brother Ted was also a PCL veteran, pitching off and on in the league from 1923 through 1934, spending 1923 and '24 in Portland and going 10-13. From 1949 through 1956, Duane pitched for the New York Yankees, St. Louis Browns, Baltimore Orioles and Philadelphia Phillies, compiling a 38-66 record. (Courtesy of the Larrance Collection.)

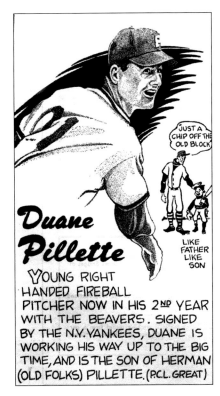

Duane Pillette

YOUNG RIGHT HANDED FIREBALL PITCHER NOW IN HIS 2ND YEAR WITH THE BEAVERS. SIGNED BY THE N.Y. YANKEES, DUANE IS WORKING HIS WAY UP TO THE BIG TIME, AND IS THE SON OF HERMAN (OLD FOLKS) PILLETTE. (P.C.L. GREAT)

JUST A CHIP OFF THE OLD BLOCK

LIKE FATHER LIKE SON

Mike Shannon played on a trio of National League pennant-winners for his hometown St. Louis Cardinals, winning World Series in 1964 and '67. On his way up, he played for Portland in 1961 and batted .230 with four home runs and 17 runs batted in. It was the first season the Beavers were a full-fledged farm team for a major league team. Shannon was an outfielder until 1967, when the Cardinals moved him to third base after acquiring Roger Maris. Shannon spent parts of nine seasons with the Cardinals, batting .255 with 68 homers and 367 RBIs. A kidney ailment forced him to retire after the 1970 season, and he went on to become a broadcaster for the Cardinals and was the proprietor of a restaurant near Busch Stadium called, appropriately, Mike Shannon's. (Courtesy of the Christiansen Collection.)

 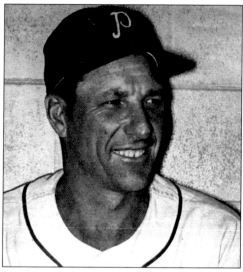

In 1962, Portland wasn't satisfied with just having a player-manager—the Beavers had a player-coach, as well. Catcher Les Peden *(above, left)*, age 39, and pitcher Gerry Staley *(above, right)*, 41, did double duty with Peden serving as manager and Staley as pitching coach. They guided the Beavers to a 74-80 record and a sixth-place finish. Peden came to Portland for his seventh year as a player-manager. He batted .351 with six home runs and 24 runs batted in for the Beavers, then returned as player-manager in 1963 but left midway through the season for San Diego. Peden graduated from Texas A&M with a degree in Mathematics and saw World War II action in the Battle of the Bulge. Staley brought 15 seasons of major league experience to Portland, having gone 134-111 with a 3.70 earned run average for the St. Louis Cardinals, Cincinnati Reds, New York Yankees, Chicago White Sox, Kansas City Athletics and Detroit Tigers. The native of Brush Prairie, Washington, was 2-4 with a 3.42 ERA with the Beavers to end his playing career. His pro career, which started in 1941, was interrupted when he served with the U.S. Army Medical Corps during World War II. (Courtesy of the Larrance Collection.)

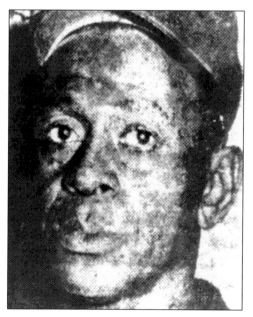

The legendary Satchel Paige pitched for Portland late in the 1961 season; it's not a great picture, but he was a great pitcher. One of the top hurlers and gate attractions of all time was signed by the Beavers in late August, 1961 to boost interest in the team and perhaps get some hitters out in the process, as Portland was in last place and drawing few fans. Paige ended up with a 0-0 record in 25 innings for Portland, striking out 19 and posting a 2.88 ERA. Not bad for someone who, as near as his age could ever be pinned down, was 55 years old and had spent the last three seasons barnstorming, including one report in *The Oregonian* that said Paige had pitched in all 83 of the Kansas City Monarchs' games that season. (Oregon Historical Society neg. ORHI 095703.)

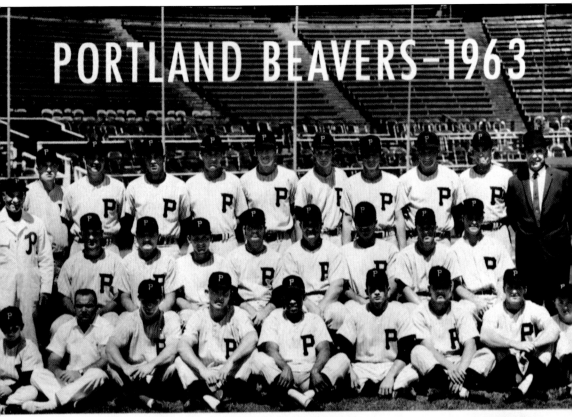

PORTLAND BEAVERS-1963

back row:
RON DEBUS, RUDY HERNANDEZ, JACK AKER, BILL KERN, JIM HUGHES, PAUL SEITZ, KEN HARRELSON, MOE DRABOWSKY, JOSE SANTIAGO, HUB KITTLE, GENERAL MANAGER.

middle row:
ROCKY BENEVENTO, JOHN WOJCIK, CHET BOAK, GORDON MacKENZIE, JIM ARCHER, LES PEDEN, MANAGER. JOSE AZCUE, LOU KRAUSSE, BOB FLYNN.

front row:
BRUCE JAYNES, BAT BOY. YOGI RUMSEY. JAY HANKINS, COACH, HAP RICHIE, HECTOR MARTINEZ, AURELIO MONTEAGUDO, DICK GREEN, BILL KIRK, LARRY NELSON, BAT BOY.

THIS EXCLUSIVE COPYRIGHT PICTURE COMPLIMENTS OF

In 1963, the Beavers finished in fourth place in the West Division with a 73-84 record but the presence of two players—Moe Drabowsky and Ken Harrelson—must have led to some fun along the way. Drabowsky (back row, third from right) was born in Poland and came to the United States in 1938 with his parents, fleeing the Nazi invasion; he began his major league career with the Chicago Cubs but a sore arm in 1958 set him to bouncing from team to team, hence his season in Portland. He was 5-1 with a 2.31 earned run average for Portland in 1963, helping a turnaround that saw him eventually go 6-0 for the Baltimore Orioles' 1966 World Series champs. Drabowsky's noted sense of humor included a variety of bullpen pranks, and it once prompted him to be pushed to first base in a wheelchair after being hit by a pitch. Outfielder Ken "Hawk" Harrelson (back row, fourth from right) was nicknamed for his beak-like nose, and he even had the moniker stitched across the back of his jersey at one point in his career. He was among the first of baseball's mod dressers in the 1960s, favoring long hair, Nehru jackets, bell-bottoms and beads. He was working his way up to owner Charley Finley's Kansas City Athletics in 1963 when he batted .300 with nine homers and 31 runs batted in. Also on the club was Dick Green (front row, third from right), the slick-fielding second baseman on the great Oakland Athletics dynasty of the early 1970s. The general manager was Hub Kittle (back row, far right). A noted storyteller, Kittle was most remembered as a pitching coach for the St. Louis Cardinals and Houston Astros and was the father of major leaguer Ron Kittle. (Courtesy of the Larrance Collection.)

OUR HATS ARE OFF!

to the members of the M. A. C.

the entire Portland Beaver Baseball Club wishes to extend their sincere appreciation to the Multnomah Athletic Club for the free rental provided them this year. Without this wonderful gesture Baseball would not have been allowed to continue in 1963.

In 1962, Portland's attendance was just 98,525—the first time it had dropped under 100,000 since 1940. To help the club make ends meet, the Multnomah Athletic Club gave the Beavers free rental at Multnomah Stadium in 1963. The team needed it, drawing just 87,438 fans that season. (Courtesy of the Larrance Collection.)

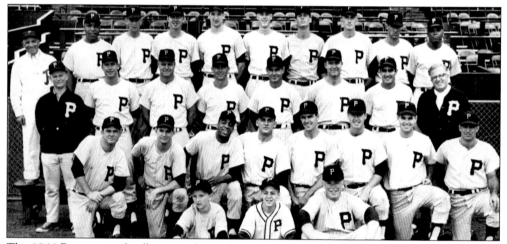

The 1964 Beavers are fondly remembered for the pitching of Luis Tiant and Sam McDowell—though neither was in the team photo—and sparking renewed interest in the club. Portland went 90-68 to place second by just one game to San Diego in the West Division, posted its best winning percentage since 1945 and drew over 200,000 fans, more than double the previous season's attendance. Outfielder Tommy Agee (second row, third from left) batted .272 with 20 home runs and 62 runs batted in pitcher Tommy John (top row, fourth from right) was 6-6 with a 5.25 earned run average; the Cleveland Indians later traded both to the Chicago White Sox. Agee was American League Rookie of the Year in 1966 and later helped New York's Amazin' Mets to the 1969 World Series title. John's major league career spanned a record 26 seasons from 1963 through 1989 and included a 288-231 record, a 3.34 ERA, and having an elbow surgery named after him. For their parts, Tiant was 15-1 with a 2.04 ERA; McDowell was 8-0 with a 1.18 ERA. The manager was John Lipon (third row, fourth from right), who guided the Beavers from 1964 through 1967 and would return to Portland as skipper in 1979. (Courtesy of the Larrance Collection.)

92

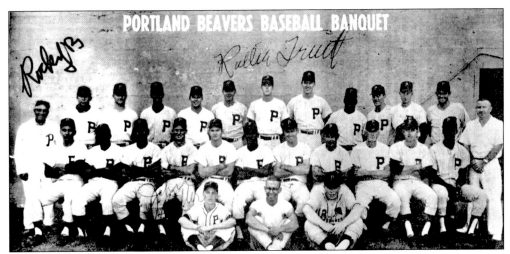

There was reason to fete the 1965 Beavers, as their boosters did with a banquet at the Eagles Lodge. By winning the Pacific Coast League's West Division with an 81-67 record, the team became Portland's first PCL first-place finisher of any sort since the 1945 champions, edging Seattle by two games. The Beavers were beaten by the Oklahoma City 89ers in the PCL Championship Series, though, losing the best-of-seven series in five games. The team landed three players on the Pacific Coast League all-star team: first baseman Bill Davis (back row, sixth from right), who batted .311 with 33 home runs and 106 runs batted in; third baseman George Banks (back row, fifth from left), who batted .279 with 35 homers and 95 RBIs; and pitcher Tom Kelley (back row, third from right), who led the league with 190 strikeouts while going 16-3 with a 2.38 earned run average. Kelley also tossed a no-hitter during the season, blanking Spokane 5-0 on May 29. (Courtesy of the Larrance Collection.)

Before Ray Fosse got knocked into baseball history by Pete Rose in the 1970 MLB All-Star Game, he was an all-star catcher for the Beavers. Fosse played in Portland in 1967 and '68, earning a place on the Pacific Coast League all-star team in 1968 when he batted .301 with 9 home runs and 42 runs batted in. Fosse was the Cleveland Indians' first pick in the first-ever June amateur draft in 1965, taken out of Marion (Illinois) High School. Fosse was called up in 1969 and became the Tribe's regular catcher in 1970, batting .307 with 18 homers and 61 RBIs. Fosse's major league career was shortened by a number of injuries but still spanned 12 years with Cleveland, the Oakland Athletics, Seattle Mariners and Milwaukee Brewers. He batted .256 with 61 homers and 324 RBIs, was named to the All-Star Game again in 1971 and earned Gold Gloves in 1970 and 1971. (Courtesy of the Larrance Collection.)

93

Lou Piniella, he of the fiery temper and sweet swing, made a splash in both the Pacific Northwest's biggest cities. Before beginning a long career as a major league player and manager—including guiding the Seattle Mariners from 1993 through 2002—Piniella went through Portland on his way up. He played the outfield for the Beavers from 1966 through '68, batting .303 with 28 home runs and 170 runs batted in. Piniella was the 1969 American League Rookie of the Year with the Kansas City Royals. After playing for the New York Yankees, Piniella became the Yankee manager, both succeeding and being succeeded by Billy Martin. He managed the Cincinnati Reds to a World Series victory in 1990 and won three division titles in Seattle before going to the Tampa Bay DevilRays. (Courtesy of the Christiansen Collection.)

John Felske's first affiliation with the Beavers came in 1970, when he was a catcher-first baseman who batted .315 with 18 home runs and 75 runs batted in; that was good for ninth in that season's Pacific Coast League batting race. He had had a cup of coffee with the Chicago Cubs in 1968 and then spent parts of the 1972 and '73 seasons with the Milwaukee Brewers. He returned to Portland in 1983 as manager and, in his only season in the job, guided the Beavers to their first Pacific Coast League championship in 38 years. He would become the Phillies' manager from 1985 through 1987, compiling a 190-194 record. (Courtesy of the Larrance Collection.)

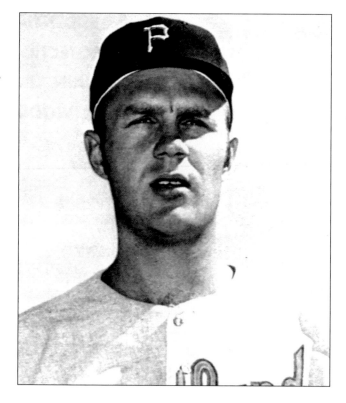

In 1970, the Beavers had a little bit of Waveland Avenue on 18th Avenue. In mid-May, a group calling itself the Bleacher Bums—the same name given the longtime denizens of Wrigley Field's outfield seats—began occupying a section of the leftfield seats at Civic Stadium. Trumpets, signs, a siren … all put some life into the largely empty ballpark. At least this time, the dummy was suspended above the ground; sometimes the Bleacher Bums dropped it from the front row toward an unsuspecting leftfielder for the visitors. One of the ringleaders of the group was Dwight Jaynes, who later became a sports columnist for The Oregonian and the Portland Tribune. (Courtesy of the Larrance Collection.)

 JOHN HUNT'S **BULLPEN** "Home of the Tickertape"

FANTASTIC SANDWICHES — BEVERAGES — ATMOSPHERE

GET SCORES OF ALL GAMES

POOL — POOL — POOL

"Just a few steps back of Center Field!!"

S. W. 18th and TAYLOR

When the Pacific Coast League reached its centennial season in 2003, Portland fans could still toast the Beavers just across N.W. 18th Street from PGE Park's left-centerfield entrance at The Bullpen. The watering hole had been a neighbor to the ballpark since at least the early 1970s, when it advertised in the team's 1972 program. (Courtesy of the Larrance Collection.)

One of the great characters on the state's baseball scene was Frank "The Flake" Peters. After lettering for Oregon State in 1963 and '64, Peters signed with the Baltimore Orioles and eventually found his way to the Beavers in 1970. He toiled in Portland for three years—once playing all nine positions in a 1972 game—and batted .276 with 11 home runs. Peters wasn't done with Portland yet, as in 1974, he became manager of the Portland Mavericks, an independent team in the Northwest League. Peters was no one-dimensional athlete, having also played guard on OSU's 1963 Final Four basketball team. He also owned a restaurant in Seattle called Peters Inn. (Courtesy of the Eskenazi Collection.)

Jimmie Reese, a Beaver coach in the early 1970s, probably had the longest career in organized baseball at 78 years. As a batboy for the Los Angeles Angels, Reese received his first professional experience when inserted into the lineup for one inning in the last game of the 1920 season at age 14. Reese played for the New York Yankees and St. Louis Cardinals from 1931 through 1933, but he spent most of 1927 through 1940 in the Pacific Coast League with Los Angeles, Oakland and San Diego. As a coach, Reese was legendary for his skill with a fungo bat, an art he practiced until he died at age 92. (Courtesy of the Eskenazi Collection.)

Wayne Twitchell played for both of the state's Triple-A franchises, Portland and Eugene. He pitched for Portland in 1970, where he produced a 9-12 record with a 5.44 earned run average, then was traded by the Milwaukee Brewers to the Philadelphia Phillies and spent most of 1971 in Eugene. Twitchell's best year was 1973, when he was 13-9 for the last-place Phils and his 2.50 ERA was second best in the National League. He also pitched in the All-Star game that year. Twitchell was a first-round draft pick of the Houston Astros in 1966. (Courtesy of the Larrance Collection.)

The final program of the Beavers' second stay in Portland showed a cherub whose frustration mirrored that of owner Bill Cutler in trying to re-invigorate minor league baseball in the city. The 1972 team drew just 91,907 fans before the franchise was transferred to Spokane for the 1973 season. Inside, the ad for the Beavers' Junior Booster Club offered kids age 18 and under the chance to join and see all 72 home games for $10. Morris Rogoway, the official jeweler of the Beavers, gave the fans one last chance to vote for Portland's most popular player for the season, who would earn a new Elgin watch. (Courtesy of the Larrance Collection.)

Seventy Years Of Portland Beaver Baseball Ends

Strike Three!

—Batter's out,
and so is the old
home team

Inside LIVING Today

Vaughn Street

Frankie and Luis

Rollie

Rocky

Moose

The Flake

The January, 1973 announcement of the Beavers' departure from Portland prompted this retrospective from the Oregon Journal in its Northwest Living section. (Courtesy of the Benevento Collection.)

EIGHT

1978–1993
Back in the Ballgame

In 1973, Portland was out of the Pacific Coast League for the first time since 1919 but the city wasn't without professional baseball. The Portland Mavericks, an independent team with no Major League affiliation, stepped into the vacancy and quickly became the outlaws of the Single-A Northwest League.

The Mavericks' antics went a long way toward bringing a larger part of Portland's sporting interest back to baseball. By 1978, the PCL was ready to expand to 10 teams and businessman Leo Ornest purchased one of the franchises, locating it in Portland and reclaiming the traditional nickname.

The Beavers were back.

Portland managed to re-establish its tie with the Cleveland Indians, the same major league team that provided the players who had given the Beavers their last era of success in the mid-1960s. The 1978 Beavers were a success on the field, going 76-62 and finishing second in the Northern Division, but they drew just over 96,000 fans—only about 5,000 more than had come through the gates in the get-out-of-town year of 1972.

Things would change the next year.

Dave Hersh, all of 23 years old, became the youngest owner in Triple-A history when he bought the Beavers prior to the 1979 season. He'd been voted the Single-A Executive of the Year in 1978 by the National Association of Baseball Executives for his work as general manager of the Appleton Foxes and he'd had similar success in 1977 as GM of the Burlington Bees.

"I'll provide the fans with exciting, traditional baseball," Hersh told *Sport* maazine during the 1979 season. "And, before and after the games, the wildest, classiest entertainment my slender checkbook can provide."

His plans included giving away $5,000 worth of diamonds to moms at the ballpark on Mother's Day, appearances by the San Diego Chicken and letting fans slide into the world's biggest glass of 7-Up in search of prizes. Buoyed by those types of promotions and a Pittsburgh Pirate-provided team that put itself in the race for the division's second-half pennant, attendance rose to almost 160,000.

Hersh's big-time plans—which originally included the goal of bringing a Major League Baseball team to Portland by 1984—outstripped his income, though. After the 1979 season, a plan to pay off the team's debts included having local businessmen Ron Tonkin and Doug Goodman assume majority stock control.

Hersh remained as vice president and general manager, and his promotional plans continued to pay off. There were exhibitions against the Pirates, including the memorable night when Willie Stargell launched a ball into the Multnomah Athletic Club balcony during a pregame home run

derby. Old-timers games and home run derbies included Hall of Famers such as Hank Aaron, Ernie Banks, Joe DiMaggio, Bob Feller, Whitey Ford, Mickey Mantle and Willie Mays.

The summer of 1981 saw no Major League Baseball for an extended period of time as the players union went on strike. That left an absence of big-league ball for Portland fans to follow, but they also had two big-league names of their own to watch that summer—Luis Tiant and Willie Horton. Hersh signed the two veterans to contracts, and their presence helped attract over 192,000 fans to Civic Stadium, the most since 1967.

By now, it had been decades since there had been any meaningful renovation of Civic Stadium. In 1980, though, voters had approved the sale of $9.5 million in bonds for improvements, and they were completed in time for the 1982 season.

The new-look ballpark helped boost attendance even further in 1982, to over 272,000 despite the Beavers finishing last in both halves of the season. That set the stage for another last-to-first story in 1983, when Portland changed its affiliation from the Pirates to the Philadelphia Phillies.

Despite a steady shuffling of players, former Beaver player John Felske guided Portland to third place during the first half of the season and then a first-place finish in the second half to reach the PCL playoffs. The Beavers beat Edmonton in the first round and then swept Albuquerque in the championship series to capture Portland's first pennant since 1945 and attendance crested at over 283,000. The Beavers went 2-2 at the Little World Series against Tidewater and Denver, placing second.

"It was a magical season, one that is just as tough to explain six months later as it was at the time it happened," *The Oregonian* sportswriter Dwight Jaynes wrote of the 1983 season in the next year's program. As for Felske, Jaynes surmised, "The 40-year-old former catcher was rock-solid through the good times and bad. He was honest with the press, the fans and the players. He was consistent. He was tough. And he got every ounce from his players."

After the 1985 season, the franchise was sold to Joe Buzas, a former New York Yankees farmhand who already owned the Phillies' Double-A team in Reading. One of his first moves was to rename Portland's franchise the Phillies, but public outcry convinced him to return the Beaver name.

Buzas' philosophy was to keep overhead and promotional costs down and live off the paid revenue from what crowds he could attract. In his first season, attendance dropped from just over 188,000 to under 140,000.

The crowds eventually steadied at around 180,000 per season. With the Minnesota Twins taking over as the parent club in 1987, the Beavers developed into a team that reached the postseason three straight years from 1991 thorugh 1993 but they were unable to get through the playoffs and win another pennant.

By 1993, Buzas' displeasure with his lease at Civic Stadium had led him to shop around for a new home. He found Salt Lake City willing to build a new ballpark, and notice that the team would move in the offseason came during the summer of 1993.

"I've been wanting to move ever since the fourth year I was here," Buzas told *USA Today* as the Beavers played their final homestand of the season. After Portland lost the PCL championship series to Tucson, he got his wish.

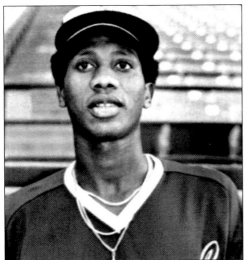

(*above, left*) Before he gained fame for getting lost on a freeway while trying to find the ballpark in Atlanta, Pascual Perez was a Portland Beaver from 1979 through 1982. The colorful Dominican righthander shot batters with an imaginary finger gun, pounded the baseball into the ground, and went 26-18 with a 4.70 earned run average. (Courtesy of the Larrance Collection.)

(*above, right*) Craig Cacek put some pop into Portland's lineup from 1979 through 1981 while the Beavers were a farm team of the Pittsburgh Pirates. Cacek batted .299 with 42 home runs and 243 runs batted in those three seasons. In 1979, he was named to the Pacific Coast League all-star team. Cacek's only look at the major leagues came in seven games with the 1977 Houston Astros. (Courtesy of the Larrance Collection.)

(*above, left*) Bob Beall, a product of Hillsboro High and Oregon State, played for both the state's Triple-A teams, Eugene in 1973 and Portland in 1980 and '81. The first baseman finished his career with the Beavers and batted .245 with 2 home runs and 24 runs batted in. He'd been in the major leagues with the Atlanta Braves and Pittsburgh Pirates during four seasons from 1975 through 1980. (Courtesy of the Larrance Collection.)

(*above, right*) As the Portland Beavers' mascot from 1979 through 1993, Round Tripper made a lot of friends for the ballclub—including these two young ladies who were on hand for the Penthouse Pets softball game in 1979. (Courtesy of the Carlson Collection.)

1980 PORTLAND BEAVERS

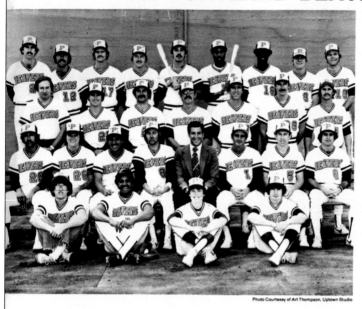

Photo Courtesy of Art Thompson, Uptown Studio

FRONT ROW:	Terry Beck, Clubhouse; Tony Pena; Rob Jackman, Batboy; Jimmy Califf, Batboy.
SECOND ROW:	Mike Tyler; Mickey Mahler; Luis Salazar; Tommy Sandt, Player-Coach; David Hersh General Manager; Jim Mahoney, Manager; Tom Trebelhorn, Coach; Jerry McDonald.
THIRD ROW:	Bill Fortinberry, Trainer; Stewart Cliburn; Gene Pentz; Dan Warthen; Mike Davey; Rick Rhoden; Gary Hargis.
FOURTH ROW:	Rick Jones; Craig Cacek; Larry Andersen; Robert Long; Rick Lancellotti; Doe Boyland; Odell Jones; Rob Ellis; Rod Gilbreath.
INSETS:	Dave Oliver; Santo Alcala; Bob Beall; Dave Hilton. Gene Cotes, Steve Farr, Vance Law.

Printing Compliments of Daily Journal of Commerce

(*above*) The 1980 Beavers finished fourth in the five-team North Division of the Pacific Coast League. The team included catcher Tony Pena (front row, second from left), known for his unique low, one-leg-out crouch behind the plate. Pena hit .327 with nine home runs and 77 runs batted in for Portland. Pena went on to become a four-time National League all-star, playing 17 big-league seasons for six different teams. The Beavers' young general manager and resident promotional genius was Dave Hersh (second row, fifth from left). (Courtesy of the Larrance Collection.)

(*left*) Pete Ward managed Portland to second-place North Division finishes in both halves of a split-season format in 1981. Ward was named Rookie of the Year by *The Sporting News* for his 1963 season with the Chicago White Sox. He started the year with a home run on opening day, which commenced an 18-game hitting streak. After the 1964 season, Ward was involved in an automobile accident, injuring his neck, and by his own admission he was never the same player. Ward's father was former National Hockey League star Jimmy Ward. (Courtesy of the Larrance Collection.)

Tom Trebelhorn was a hometown boy who eventually managed the hometown team. He played at Cleveland High, then at Portland State. In his five seasons as a professional catcher, Trebelhorn advanced as high as Double-A. Trebelhorn then began working his way up the ladder as a coach and manager, returning to the Portland area in the off-season to teach school. His year guiding the Beavers was 1982, when they finished fifth in the North Division with a 65-79 record. Trebelhorn managed in the major leagues with the Milwaukee Brewers—at one point leading them to a 13-game winning streak—and Chicago Cubs and was later a coach with the Baltimore Orioles. (Courtesy of the Larrance Collection.)

Odell Jones was already a much-traveled veteran when the right-handed pitcher landed in Portland in 1980. He started his pro career in 1972 and had already worked his way up to the major leagues with the Pittsburgh Pirates and Seattle Mariners before becoming a Beaver. Playing on the Beavers' veteran-laden teams of the early 1980s, Jones was 34-22 with a 3.98 earned run average from 1980 through 1982. In 1982, he led the Pacific Coast League in wins by going 16-9 with a 4.26 ERA. He also led the PCL in strikeouts with 135 in 1981 and 172 in 1982. He spent the next two seasons with the Texas Rangers and also pitched for the Milwaukee Brewers in 1998. Jones was back in the PCL when he wrapped up a 21-year pro career in 1992 with Edmonton. (Courtesy of the Larrance Collection.)

103

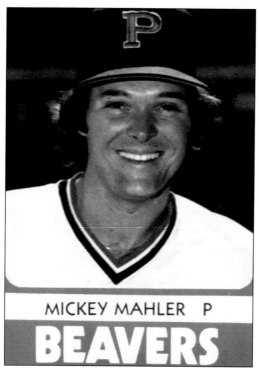

MICKEY MAHLER P

BEAVERS

Mickey Mahler was a starter for the Atlanta Braves in 1978 and '79 but was released in 1980. He latched on with the Pittsburgh Pirates and was sent to Portland, where he had a 14-8 record and 2.65 earned run average; he led the Pacific Coast League with 140 strikeouts and 14 complete games. By the time his career ended after the 1987 season he'd pitched for the Pirates, California Angels, Detroit Tigers, Montreal Expos, Texas Rangers and Toronto Blue Jays. Mahler was also the winningest American pitcher in Dominican Winter League history, compiling 41 victories. (Courtesy of the Larrance Collection.)

In 1980, the *Oregon Journal* combined boosting the Beavers with boosting its circulation with Beaver Buck$. The contest tied the team's on-field performance with prizes for readers who had submitted entries to the newspaper. Within two years, the *Journal*—Portland's afternoon newspaper—had been merged into *The Oregonian*, the morning newspaper. (Courtesy of the Carlson Collection.)

Price $1.00

Hit

Official Magazine of the Portland Beavers

Ageless pitcher Louis Tiant played for Portland Beavers in 1964 and 1981. His professional career began in 1959 and he has played 19 years in the Major Leagues. Tiant will be remembered.

EASTMAN KODAK

Not only did Luis Tiant pitch for Portland in 1964 on his way up to the Major Leagues, but on his way down, as well. In 1981, after 17 seasons with the Cleveland Indians, Minnesota Twins, Boston Red Sox and New York Yankees, Tiant found himself without a major league contract despite having over 200 big-league wins. Portland signed the 40-year-old veteran to a contract of over $100,000 in an effort to conjure up longtime fans' memories of some good Beaver seasons in the mid-1960s. Tiant went 13-7 for the Beavers with a 3.82 earned run average, striking out 111 hitters while walking just 49 in 146 innings. The Beavers' attendance jumped from 129,814 in 1980 to 192,214 in 1981; it didn't hurt that the major leagues were on strike much of the summer, making the Beavers part of the highest-level baseball being played. The Beavers have treated me real good," said Tiant, who no-hit Spokane on April 18. "The people are nice to me all over the league, wherever I go. When I was here the first time (in 1964, going 15-1), I had just two or three pitches. Now, I know how to pitch." Portland's parent club, the Pittsburgh Pirates, eventually bought Tiant's contract for the close of the 1981 season; he was 2-5 for the Bucs with a 3.92 ERA. Tiant then finished his career in 1982 with the California Angels. (Courtesy of the Carlson Collection.)

LARRY ANDERSEN P

BEAVERS

Larry Andersen, a Portland native, holds the distinction of having played for the Beavers while a member of three different major league farm systems—the Cleveland Indians' in 1978, when he had a 10-7 record and 3.45 earned run average; the Pittsburgh Pirates' in 1980, when he was 5-7 with a 1.74 ERA; and the Philadelphia Phillies' in 1983, when he was 7-8 with a 2.05 ERA for the Pacific Coast League champions. He also pitched for the Phillies that season as they won the National League pennant, going 1-0 with a 2.39 ERA. In 12 seasons in the Major Leagues with the Indians, Seattle Mariners, Phillies and Houston Astros, Andersen went 27-28 with a 3.33 ERA and earned a reputation as one of baseball's foremost clubhouse pranksters. (Courtesy of the Larrance Collection.)

Juan Samuel managed to play for a pair of pennant-winners in 1983. The second baseman spent much of the season with Portland's Pacific Coast League champions, batting .330 with 15 home runs and 52 runs batted in; that earned him a late-season call up to the Philadelphia Phillies, who took the National League pennant before losing the World Series to the Baltimore Orioles. The next year, he was *The Sporting News'* Rookie of the Year honors for the NL. Samuel had also begun his minor league career in the state, for the Central Oregon Phillies of the Northwest League in 1980. Samuel remained in the major leagues through 1997 with seven teams. (Courtesy of the Larrance Collection.)

BEAVERS Juan Samuel
 2nd Baseman

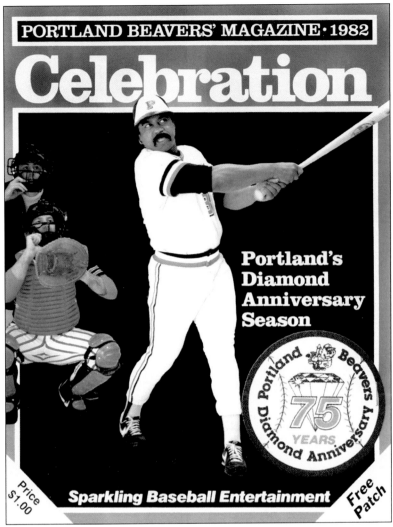

The Beavers began the 1981 season with 17 players possessing Major League experience, and the best-known after Luis Tiant was slugger Willie Horton. The outfielder-designated hitter had spent the previous 19 years with the Detroit Tigers (including the 1968 World Series champs), Texas Rangers, Cleveland Indians, Oakland Athletics, Toronto Blue Jays and Seattle Mariners; during that time, he'd batted .273 while accumulating 325 homers and 1,163 runs batted in. Horton, like Tiant, was part of an effort by Beaver general manager Dave Hersh to give Portland as much of a big-league feel as possible. Signed at age 37, Horton played the 1981 and '82 seasons with the Beavers, batting .286 and slugging .481 with 39 homers and 157 runs batted in—and somehow managing a triple each season. "I'm glad I made a decision to come here to Portland," Horton said in 1981. "I make my living expenses, stay in shape, and I'm playing baseball—that's the important thing … I know I can still play in the big leagues. I wouldn't be here otherwise." Horton, though, never returned to the major leagues after his stint with the Beavers. Note the lower right corner of the program cover. The Beavers celebrated their diamond anniversary in 1982, and this patch was given away stapled to the front cover of game programs. Exactly how that 75th anniversary figure was arrived it isn't entirely clear; it was actually the Beavers' 74th season in the Pacific Coast League and 79 years since Portland first joined the PCL. (Courtesy of the Carlson Collection.)

By 1983, Portland's pennant drought in the Pacific Coast League had reached 38 years. The Beavers' affiliation moved from the Pittsburgh Pirates to the Philadelphia Phillies, and the arrangement proved beneficial to both parties. Portland won its first PCL championship since 1945, and the Phillies took the National League flag for the second time in five years. Charlie Hudson (second row, sixth from right) was 6-3 with a 2.67 earned run average before being called up; he eventually earned a win in the NL playoffs. Also splitting time between Portland and Philadelphia that summer were pitchers Kevin Gross (second row, seventh from right), Porfi Altamirano (front row, fifrth from left) and Larry Andersen (second row, sixth from left); infielders Kiko Garcia (not pictured) and Steve Jeltz (front row, fourth from left), first baseman Len Matuszek (second row, fourth from right) and second baseman Juan Samuel (not pictured). John Russell (second row, fifth from left) was one of many talented players who contributed to Portland's 1983 PCL championship, but he was one of the few who were with the Beavers all season. The outfielder batted .254 with 27 home runs, 23 doubles and 75 runs batted in. Russell also spent most of 1984 and part of 1985 with the Beavers between stints in Philadelphia. He was moved to catcher in 1986 and played in the major leagues with the Phillies, Atlanta Braves and Texas Rangers through 1993. (Courtesy of the Carlson Collection.)

It's a sunny summer afternoon in 1987, the Jantzen lady above leftfield is looking on approvingly, and taking a cut for the Beavers is outfielder Billy Beane. He's the same Billy Beane who would later become general manager of the Oakland Athletics in the late 1990s and shake up the game by emphasizing player evaluation based on on-field performance rather than physical potential—the subject of the 2003 book *Moneyball*. Beane batted .285 for the Beavers in 1987, hitting eight home runs and driving in 71 runs. (Courtesy of the Carlson Collection.)

(*above, left*) Philadelphia Phillies' farmhand Darren Daulton spent 1984 and part of 1985 as the Beavers' catcher, hitting .298 over that span, but hitting just nine home runs to display little of the power he would show with the Phils. Daulton was a three-time major league all-star and played in two World Series—in a 1993 loss with Philadelphia and a 1997 victory with the Florida Marlins. (Courtesy of the Larrance Collection.)

(*above, right*) Rick Schu began his minor league career in 1981 with the Bend Phillies and worked his way to Portland, where he played from 1983 through 1985. Schu hit .301 with 14 triples and 12 home runs for Portland in 1984. He played for five teams in a nine-year career in the major leagues. (Courtesy of the Larrance Collection.)

(*above, left*) Brian Harper, always considered a better hitter than a catcher, played 101 games for the Beavers as part of the Pittsburgh Pirates' organization in 1982, hitting .284 with 17 home runs and 73 runs batted in. He returned in 1988 as a member of the Minnesota Twins' system, batting .353 with 13 homers and 42 RBIs. (Courtesy of the Larrance Collection.)

(*above, right*) The 1987 season was the first time Pat Casey wore a jersey with "Beavers" stitched across the chest, but it wouldn't be the last—eight years later, he became head baseball coach at Oregon State. Casey, a product of Newberg High and the University of Portland, batted .215 with 3 homers and 13 runs batted in. (Courtesy of the Larrance Collection.)

ProCards®

KELVIN TORVE
First Base
Portland Beavers

Kelvin Torve was a left handed-hitting, right handed-throwing first baseman for the Beavers in 1988 and 1989; that doesn't explain why he seems to be masquerading as a left handed pitcher for the photographer, but the pose might explain the slightly-suppressed smirk he seems to be wearing. With Portland, the South Dakota native hit .295 with 17 home runs and 109 runs batted in; in 1989, led the Pacific Coast League with 41 doubles. He had late-season calls to the major leagues with the Minnesota Twins in 1988 and with the New York Mets in 1990 and 1991. (Courtesy of the Larrance Collection.)

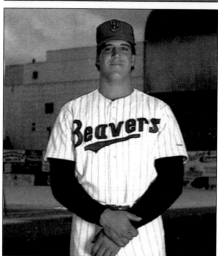

(above, left) Paul Sorrento spent most of 1990 and '91 in Portland, establishing himself as one of the brightest stars in the Minnesota Twins' system. A model of consistency, Sorrento hit .302 with 19 home runs and 72 batted in during 1990, then followed that up by hitting .308 with 13 homers and 79 RBIs in 1991. He was traded to the Cleveland Indians just before the start of the 1992 season and proved to be a solid major league hitter with good power. (Courtesy of the Larrance Collection.)

(above, right) Willie Banks pitched for the Beavers' postseason clubs in 1991 and '92 en route to a well-traveled career in the major leagues. The right-hander had a 15-9 record and 3.66 earned run average in his two Portland seasons. In 1991, he pitched briefly for the Minnesota Twins' World Series champs, going 1-1 with a 5.71 ERA. (Courtesy of the Larrance Collection.)

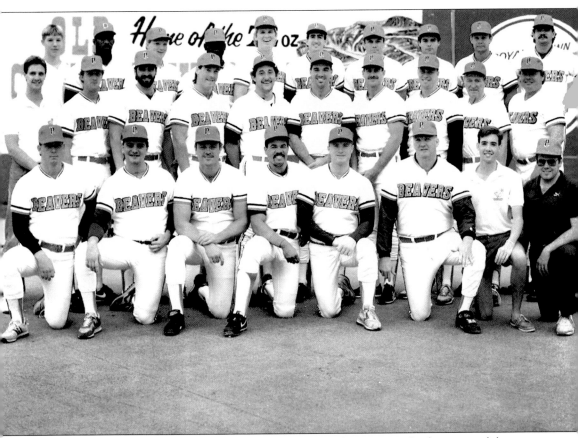

In 1987, the Beavers became part of the Minnesota Twins' farm system. As the parent club won its first World Series title, Portland got cast of characters gathered from near and far that finished 45-96 and placed fifth in both halves of a split-season format. Manager Charlie Manuel (front row, third from right)—who would later manage the Cleveland Indians—had played for the Kinetsu Buffaloes in the early 1980s and had also played for the Beavers in 1971. Portland also had a number of Willamette Valley products on its 1987 roster. Jim Wilson (second row, fourth from left) had graduated from Crescent Valley High in Corvallis and played both baseball and football at Oregon State; Tom Gorman (second row, fifth from left) had pitched Woodburn High to a state championship before starring at Gonzaga. Pat Casey (not pictured) had been a three-sport star at Newberg and played both college baseball and basketball at Portland. By the end of his 18-year professional career, Terry Forster (second row, far right) was more noted for his alleged gluttony than his pitching; if his career was a meal, his brief stop in Portland was dessert. In 1987, Forster was 0-1 with a 7.27 earned run average for the Beavers, appearing in 13 games in his final season. A few years before, late-night television host David Letterman had called Forster "a fat tub of goo"; the then-Atlanta Brave later went on Letterman's show for a cooking segment, preparing chicken enchiladas. In a 16-year Major League career with the Chicago White Sox, Pittsburgh Pirates, Los Angeles Dodgers, Braves and California Angels, the lefthander had a 54-65 record with 127 saves and a 3.23 ERA. He led the American League in saves with 24 for the 1974 White Sox. (Courtesy of the Larrance Collection.)

ProCards®

BERNARDO BRITO
Outfield
Portland Beavers

Bernardo Brito made a habit of stopping traffic out on 18th Avenue during the last few years of the Beavers' third stint in Portland. An outfielder for the Beavers from 1989 through 1993, the right-handed slugger launched 120 homers in his five seasons in Portland, many carrying over the leftfield bleachers at Civic Stadium. He also drove in 404 runs, batting .278 and slugging .520. He added 100 doubles and 22 triples to his homers to give him over 1,000 total bases as a Beaver—1,061, to be exact. In 1993, he hit .339 with 20 homers, 72 runs batted in, 18 doubles and 3 triples while spending just 83 games with the Beavers. On August 4, 1991, Civic Stadium was packed with 17,741 fans to see former Los Angeles Dodger Fernando Valenzuela pitch for Edmonton. Brito stepped in and banged a shot estimated at 500 feet off the scoreboard behind the left-centerfield bleachers as the Beavers won 7-3. Brito did earn looks from the Minnesota Twins in 1992, '93 and '95. (Courtesy of the Larrance Collection.)

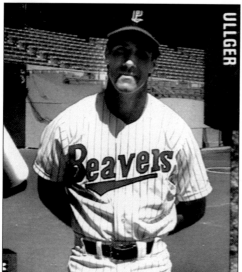

(*above, left*) Scott Ullger managed the Beavers in 1992 and '93, taking them to the playoffs in each of the final two years of their third stay in Portland. Drafted by the Minnesota Twins in the 18th round in 1977, Ullger spent 11 years in the minor leagues, making it to the Twins for 35 games in 1983. (Courtesy of the Larrance Collection.)

(*above, right*) Joe Buzas operated 82 teams over the course of his lifetime, including the Portland Beavers from 1985 through 1993. Buzas had spent a decade as a minor league player from 1941-50, and he reached the Major Leagues when he played 30 games for the New York Yankees in 1945. (Courtesy of the Carlson Collection.)

Nine

2001–2003
Let's Try Again

Portland's second break from Pacific Coast League baseball had lasted five seasons; the city's third sabbatical lasted seven. And, as it had the last time around, it took a successful Northwest League franchise to demonstrate Portland's interest in the game.

After going without professional baseball in 1994—the city's first season without a club since 1900—Portland regained a team when the Bend Rockies moved west of the Cascades for the 1995 season. Strong promotions and a family atmosphere got Portlanders back in the habit of heading for Civic Stadium in the summertime, and that once again led to speculation about a return to the PCL.

By 2000, the city of Portland and a group known as Portland Family Entertainment (PFE) came to an agreement that would have PFE operating a renovated Civic Stadium. PFE was headed by Marshall Glickman, who had been president of the Portland Trail Blazers from 1988 until 1995. Marshall's father, Harry Glickman, had been a longtime sports promoter in Portland and was the driving force in the city getting the Blazers; Harry was named president of PFE.

A $38.5 million makeover of Civic Stadium would give PFE the stage on which to showcase a yet-to-be-obtained PCL franchise, the Portland Timbers of pro soccer's "A League," Portland State football, high school football, concerts and international soccer matches.

A deal to buy the Calgary Cannons fell through, but PFE was able to purchase the Albuquerque Dukes and it was announced that the PCL would return to Portland in 2001. And, in midwinter of 2000-01, it was announced that the team's nickname would, indeed, again be "Beavers."

In many ways, the Beavers' first season back in Portland was a success.

The team was part of the San Diego Padres' farm system and it finished third in the four-team Northern Division with a 71-73 record. But the ballpark—now known as PGE Park after naming rights were sold to Portland General Electric—drew mostly good-to-great reviews.

"Beyond mere climate, though, PGE Park is a pretty cool ballpark. Cool in an old-time sense, anyway," wrote Chris Jenkins of the *San Diego Union-Tribune*, sent north to check out the new Triple-A club of the newspaper's hometown team. "You can get a shave and a haircut and a shoeshine in the concession concourse, harkening back to the days when "Sudden Sam" McDowell and Luis "El Tiante" Tiant both pitched for the Beavers."

Portland catcher Rick Wilkins told Jenkins: "Coming up with the (Chicago) Cubs, I love the old ballparks, and what I've noticed about this one is how loud it gets … a crowd of 5,000 here sounds like 15,000."

Added manager Rick Sweet: "It is unique. The ballpark has real personality, a tremendous personality. It's old-fashioned baseball. All the popcorn is popped right here at the ballpark. The peanuts are roasted right here. The noise is booming in here during games."

The fans liked it, as 439,686 came through the gates to break a season attendance record that had stood since 1947; the Beavers had only drawn over 200,000 three times during their stay from 1978 through 1993 and they hadn't drawn over 300,000 since the 1956 season, their first at what was then Multnomah Stadium.

PFE tried for a major league environment in every way possible, and while it made for a boost in attendance it also made for a boost in the ballclub's bills. Sponsorships and sales of the ballpark's new suites hadn't reached expectations, so PFE's investors ousted Glickman's management group at the end of the season.

The investors brought in the Goldklang Group as consultants to the franchise. One of Goldklang's best-known names was Mike Veeck, son of legendary baseball owner Bill Veeck; when his dad owned the Chicago White Sox in the late 1970s, it was Mike who came up with the idea of holding the "Disco Demolition Night" promotion that led to the Sox forfeiting the second game of a doubleheader.

Hence, no one should have been that surprised when August 17—the birthday of both Babe Ruth and Elvis Presley—was pronounced "Two Fat Dead Guys Night" and anyone showing up at the gates dressed as either corpulent corpse would be admitted to the game free. Again, there was a new season attendance record as 454,197 came to the park.

By the start of the 2003 season, a campaign was well underway to bring Major League Baseball to Portland, most likely in the form of the Montreal Expos. That attracted a good deal of Portland's baseball attention.

PFE, behind in rent payments to the city of Portland, defaulted on its loan and that put the TIAA-CREF pension fund in charge of the team. Some late-season marketing helped the Beavers pass the 400,000 mark in attendance once again.

The Beavers led the division for much of the early part of the season and stayed in contention well into August, but they were in the spotlight for a bizarre reason in the middle of the month. At the end of a game in Las Vegas, a number of Beavers hopped the railing and chased a heckler through the stands; the man later alleged that he had been assaulted by Portland players. The PCL suspended and fined 19 Beavers for the incident. Portland went into the final series of the Beavers' centennial season with a chance to make the playoffs with a sweep but couldn't pull it off.

When the Beavers returned to Portland in 2001, they made themselves at home in newly-renovated PGE Park. A $38.5 million renovation turned the former Multnomah Stadium and Civic Stadium into a minor league version of the "retro" ballparks that had sprouted in Major League Baseball in the 1990s. (Courtesy of the Andresen Collection.)

When Portland returned to the Pacific Coast League in 2001, the Beavers had a home-grown manager. Rick Sweet grew up in nearby Longview, Washington, and had maintained a home in Vancouver prior to getting the job with the Beavers. Sweet had reached the majors as a catcher with the San Diego Padres in 1978 and also played for the New York Mets and Seattle Mariners before retiring as a player in 1982. Ironically, Sweet had also managed in the last game the Portland Beavers played in 1993 before the franchise was moved to Salt Lake City— Sweet guided Tucson past Portland in the PCL championship series that season, four games to two. In the Beavers' 2001 program, broadcaster Rich Burk asked Sweet about his childhood memories of games in Portland. "The main thing I remember was how much fun it was to go to the ballpark, and how big the players looked," Sweet said. "I was young, but I can remember getting to go to the stadium, and being from a small town like Longview, the pure size of the stadium was amazing." Returning to manage a team in the Pacific Northwest was, well, sweet. "I'm damn proud of this area," Sweet told Chris Metz in the Beavers' 2003 program. "Players that come to play for me know I'm from here. I want players to leave here knowing that it's a great place to live and a great place to play ... I feel more responsible here. I want to make this (Portland's return to the PCL) work big-time. I want everything to be as perfect as it can be." (Courtesy of the Portland Beavers.)

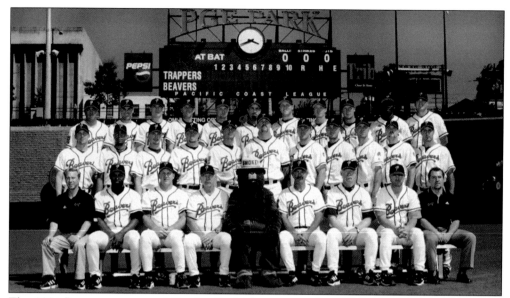

The 2001 Beavers represented Portland's third return to the Pacific Coast League, following in the footsteps of the 1919 and 1978 teams. This time, Portland had a West Coast team for a major league affiliate for the first time ever as the San Diego Padres were the Beavers' parent club. The closest Portland had come to a West Coast affiliation had been in 1970, when they were aligned with the Seattle Pilots during the winter but the Pilots became the Milwaukee Brewers just prior to the start of the season. (Courtesy of the Portland Beavers.)

Opening Day of the 2001 season was cause for celebration as Portland not only returned to the Pacific Coast League, but also got its first look at newly renovated PGE Park. The opener had been pushed back because of construction delays, with the Beavers playing their initial home games in Pasco, Washington; that was where the Single-A Portland Rockies had been moved when the PCL returned to Portland. (Courtesy of the Portland Beavers.)

Bill Schonely was one of the most beloved figures in Portland sports history long before he began broadcasting the Beavers' games when they returned to the city in 2001. Schonely was the play-by-play man for the National Basketball Association's Portland Trail Blazers from the team's inception in 1970 until the Blazers let him go in 1998. Baseball was how Schonely had arrived in the Pacific Northwest; he was one of the broadcasters for the Seattle Pilots in their lone American League season of 1969. Schonely's "bingo-bango-bongo" call that Blazer fans heard describe the ball movement on a fast break had been his call for a team turning a double play. (Courtesy of the Portland Beavers.)

The greatest leadoff hitter in baseball history was also the first-ever hitter for the third reincarnation of the Beavers. On April 5, 2001, Rickey Henderson stepped in to begin Portland's Opening Day contest at Tucson. While Henderson played for Portland, he never played in Portland—he was called up to the San Diego Padres after just nine games, and the Beavers opened the season with a 24-game road trip while renovations to PGE Park were completed. While with the Beavers, Henderson batted .275 threw in one example of his prime talent—a stolen base. (Courtesy of the Portland Beavers.)

Carlton Loewer spent most of 2001 with the Beavers and had a 5-4 record and 3.87 earned run average. He also took a pair of losses for the San Diego Padres that season. Injuries kept Loewer out of action for the entire 2002 season, but he came back to go 7-8 with a 5.40 earned run average for the 2003 Beavers. He was called up by the Padres where he made five starts, posting a 1-2 record with a 6.65 ERA. By the time the Padres obtained him in a 1999 trade, the righthander out of Mississippi State had already played part of 1998 and '99 for the Philadelphia Phillies. He was a first-round pick of the Phillies in 1994. He'd also been taken by the Toronto Blue Jays in the seventh round after his senior season at St. Edmund High in Louisiana, where he was a four-year letterman in baseball, basketball and track and field. (Courtesy of the Portland Beavers.)

Junior Herndon went 7-13 with a 5.26 earned run average for Portland in 2002, but the righthander from Craig, Colorado, pitched the first no-hitter of the Beavers' fourth stay in Portland when he blanked Tacoma 5-0 in the seven-inning second game of a doubleheader on May 15. It was the Beavers' first no-hitter since 1992, when David West, Larry Casian and Greg Johnson had combined on one; the last Beaver to go the distance in a no-hitter had been Luis Tiant in 1981. Herndon had also pitched for Portland in 2001, going 9-5, and he reached the majors with the San Diego Padres long enough to post a 2-6 record. (Courtesy of the Portland Beavers.)

During the Beavers' 100th anniversary season, Brady Anderson became the first player in team history who joined the club having already been named Most Valuable Player at MTV's "Rock 'n' Jock" softball game. That honor came in the network's 1998 faux classic, and the fact he'd been in that game gives some idea of the major league career he'd enjoyed before becoming a Beaver. Anderson had played 15 seasons in the bigs with the Baltimore Orioles and Cleveland Indians, batting .256 with 210 home runs and 761 runs batted in. While with the Orioles, he started the Brady Anderson Charitable Community Fund. With the Beavers in 2003, he got only 68 at-bats, batting .294 and driving in seven runs. (Courtesy of the Portland Beavers.)

Jason Bay helped Portland to an early lead in the 2003 Pacific Coast League Northern Division race, then the outfielder was called up by San Diego on May 3 and played three games before injuring his wrist and going on the disabled list. He returned to the Beavers in July and was hitting .303 with 20 home runs, 59 runs batted in and 23 stolen bases when the Padres traded him to the Pirates. Bay was a World Series veteran before he ever signed a professional contract, having played for Canada in the 1990 Little League World Series. (Courtesy of the Portland Beavers.)

Bernie Castro came from baseball country—Santo Domingo in the Dominican Republic, the hometown of Major League stars Cesar Cedeno, Pedro Martinez and Manny Ramirez, among others. The switch-hitting second baseman was the Pacific Coast League's stolen base champion in 2003, swiping 43 in 49 attempts. He also batted .309 with two home runs, five triples and 17 doubles while driving in 24 runs. Castro had never stolen fewer than 53 bases in any of his previous four professional seasons. Castro's 2003 season earned him a place on the PCL all-star team; he was the first Beaver selected since Portland returned to the league in 2001. (Courtesy of the Portland Beavers.)

Dennis Tankersley was the Pacific Coast League strikeout champion in 2003, using an outstanding breaking pitch to fan 148 batters on the way to an 8-11 record and 4.65 earned run average. The lefthander from St. Charles, Missouri, had been named the No. 2 prospect in the San Diego Padres organization going into the year. He'd originally signed with the Boston Red Sox and was acquired by San Diego in a trade during the 2000 season. Tankersley spent part of the next two seasons with the Beavers, going 1-2 with a 6.91 ERA in 2001 and 3-4 with a 388 ERA in 2002. He made his major league debut in San Diego in 2002. (Courtesy of the Portland Beavers.)

TEN

The Others

While the Portland Beavers dominate the history of professional baseball in Portland, they have had a number of predecessors and successors. In fact, two teams—the Mavericks and the Rockies—fit both descriptions.

There were numerous semipro outfits in the latter part of the 19th Century, but the first truly professional nine was the 1890 Portland Webfeet. Along with Tacoma, Spokane, and Seattle, they comprised the newly-formed Pacific Northwest League, run by William H. Lucas. The league was not recognized by organized baseball in its first two seasons, but achieved that designation for 1892 and promptly disbanded at the end of that season.

In 1896 the New Pacific League came to town in the guise of the Portland Gladiators. That league disbanded in midseason with Portland in first place.

In 1901, professional baseball came to stay. Lucas was back with a newly formed Pacific Northwest League and the Portland team—again known as the Webfeet or Webfooters—played in a brand new ballpark, at 24th and Vaughn. The park was built and owned by Portland's two warring streetcar companies. It was a rare moment of cooperation, but both parties understood the mutual benefit to their business. The 1901 edition of the Webfeet featured a 19-year-old Montana shortstop by the name of Joe Tinker, who within a few short years would be leading the famed Tinker-to-Evers-to-Chance double play combo for the Chicago Cubs.

In December 1902, Henry Harris, president of the San Francisco club of the outlaw California League, came to town and proposed that the Pacific Northwest League clubs in Portland and Seattle jump to his new Pacific Coast League, slated to start operations for the 1903 season. Portland made the leap, but Daniel Dugdale, owner of the Seattle team, chose to cast his lot with Lucas and the Pacific Northwest League. The PCL put a team in Seattle to compete with Dugdale and the PNL entry was gone after the 1903 season. As the PCL celebrated its centennial season in 2003, Portland was the only member of the league that had been part of the circuit in its first season.

Lucas was determined to go head-to-head with the PCL with a re-formed league, now known as the Pacific National League. Portland's entry, the Greengages, lasted just half of the 1903 season before moving to Salt Lake City. Lucas' league continued in 1904, then reorganized again in 1905 to become the Northwestern League. The league lasted into the 1917 season before shutting down permanently in July.

In an interesting side note, Fielder Jones—famous manager of the 1906 Chicago White Sox "Hitless Wonders"—had quit the Sox after the 1908 season in a dispute with Sox owner Charles Comiskey and moved to Portland to look after his timber interests. After coaching the baseball team at Oregon Agricultural College (now Oregon State University) to the Pacific Northwest

championship and playing for Centralia in the Washington State League in 1910, Jones became president of the Northwestern League from 1911 until the middle of the 1914 season. He then returned to the major leagues, managing the St Louis Terriers of the Federal League, and then the St. Louis Browns of the American League.

Portland re-entered the Northwestern League in 1909 and again from 1911 through 1914. The teams were owned by Judge W.W. McCredie and Walter McCredie, who had purchased the Beavers in 1905. This squad, known as the Colts, was a farm team of the Beavers until they were sold and moved to Ballard, Washington, in the middle of the 1914 season.

In 1918, Portland was dropped from the PCL because of travel difficulties brought on by World War I; with no Seattle team in the league at that time, it was impractical to send clubs from California to the Pacific Northwest to play just one opponent. Instead, Portland fielded a club in the Pacific Coast International League. After several teams dropped out, the league folded in early July. Portland re-entered the PCL in 1919, as did Seattle, absent since 1906.

The Beavers were then a continuous presence in Portland until after the 1972 season, when the franchise was moved to Spokane. Into the breach stepped the Portland Mavericks, an independent team in the short-season Single-A Northwest League. This was a squad of players who were older—and rowdier—than the just-drafted youngsters in the rest of the league, and the Mavs terrorized the circuit for five years. During 1977, the team included both former major league pitcher and *Ball Four* author Jim Bouton, who was staging a comeback that would eventually return him to the majors, and actor Kurt Russell, son of team owner Bing Russell and a fine ballplayer until suffering an injury several years before.

The Beavers and the PCL returned to Portland in 1978. However, owner Joe Buzas moved the team to Salt Lake City after the 1993 season and Portland spent the summer of 1994 without professional baseball for the first time since 1899. In 1995 Jack and Mary Cain transferred the Northwest League's Bend franchise to Portland, where it remained for six years, winning the league championship in 1997. Portland again re-entered the PCL in 2001.

Joe Tinker was the shortstop in the famed "Tinker-to-Evers-to-Chance" Chicago Cubs infield immortalized in a poem by Franklin P. Adams; all three infielders are in the Hall of Fame. After playing one year of professional baseball in Montana, the Kansas-born, 19-year-old Tinker arrived in Portland to play shortstop for the 1901 Portland Webfooters of the outlaw Pacific Northwest League. A light hitter but slick fielder, he made a sufficient impression that he was sold to the Chicago Cubs, where he became their starting shortstop beginning in 1902 and held the post for 11 years.(Courtesy of the Ranta Collection.)

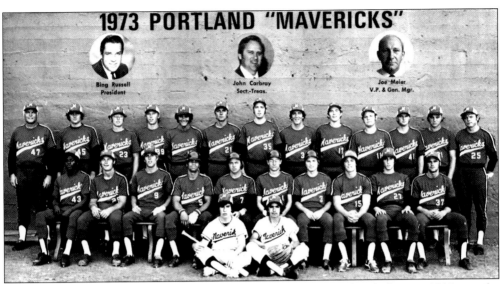

The first non-Beaver team to represent Portland in professional baseball since 1918 was the 1973 Portland Mavericks of the Single-A Northwest League. The team was owned by actor Bing Russell (upper inset, far left), a long-time baseball fan probably best known for his 10-year run as Deputy Clem Foster on the television show Bonanza. The original Mavericks drew just over 80,000 fans—only about 10,000 fewer than the 1972 Beavers had, despite playing a season only about half as long. When the Pacific Coast League returned to Portland for the 1978 season, Russell was awarded $206,000 for the loss of his team. (Courtesy of the Larrance Collection.)

By 1975, the Mavericks had pretty much let their hair down—literally, in the case of owner Bing Russell (second row, seventh from left). The offbeat tenor of the team continued as Frank Peters (second row, sixth from left) was manager, and he's reaching across Russell to shake hands with a rather unlikely member of the Mavs—Ralph Coleman (second row, fifth from right). Coleman had been Peters' coach at Oregon State, where Coleman coached for 35 seasons from 1923 through 1966, with the dapper gentleman coaching he Beavers into the 1952 College World Series. Coleman pitched for the Portland Beavers in 1921 and '22 before returning to his alma mater to coach. Coleman later pitched in one game for the Beavers in 1925 and one for Oakland in 1926. (Courtesy of the Larrance Collection.)

1977 PORTLAND MAVERICKS

For a short-season Single-A team, the 1977 Mavericks had some high-profile individuals. Pitcher Jim Bouton (20th from left) had been something of a star for the New York Yankees in the 1960s, something of a pariah in the major leagues after his book *Ball Four* described his 1969 season with the Seattle Pilots and Houston Astros, and something of an underdog when he tried to make it back to the bigs in the 1970s. He had pitched briefly for the Mavericks in 1975 and returned to the team two years later, going 9-2 with a 3.55 earned run average in his Mavs career. He did make it back to the Atlanta Braves in 1978, going 1-3 in 5 starts. Bouton, who won 21 games for the 1963 Yankees, finished his major league career with a 62-63 record and 3.57 ERA. Sitting in the bullpen one night, Bouton watched his much younger teammates chewing tobacco. Fellow pitcher Rob Nelson said it was too bad they didn't make gum that looked like chewing tobacco. From that idea came Big League Chew, a very successful product. Also on that final Mavericks team was actor Kurt Russell (10th from left), son of owner Bing Russell. Kurt Russell was better known as an actor in Disney films at the time, but he'd been an outstanding ballplayer in his youth and reached the Double-A level in the California Angels' farm system as an infielder before a rotator cuff injury effectively ended his career. Russell had two brief flings with the Mavericks. (Courtesy of the Carlson Collection.)

The 1997 edition of the Portland Rockies won the Northwest League's Southern Division, then defeated Northern Division champ Boise to take the championship. Portland's Jim Eppard was named Northwest League Manager of the Year, and relief pitcher Ara Petrosian was named to the all-star team. The team paced the league in attendance, drawing over 212,000 fans. Noted players on the team included Juan Pierre, centerfielder for the 2003 World Series champion Florida Marlins. Pierre was the Colorado Rockies' centerfielder from 2000 through 2002 and was the National League stolen base champion in 2001 and '03. Also pictured is the wonderfully named Chone Figgins, who played in 86 games over 2002 and '03 for the California Angels. (Courtesy of the Andresen Collection.)

Jack Cain and his wife, Mary, earned high regard in Oregon baseball circles after purchasing the Bend team in the short-season Single-A Northwest League in 1980. Jack Cain, in fact, served a six-year term as league president. When the Beavers left Portland after the 1993 season, the city went a season without baseball before the Cains moved their team to Portland. The Cains were named Minor League Executives of the Year by *The Sporting News* in 1995 for their management of the Portland Rockies. (Courtesy of the Andresen Collection.)

Year by Year Summary

Year	Team	Record	Pct.	Place	G.B.	Manager	Att.	P.C.L. Leaders	All-Stars
1903	Browns	95-108	0.468	5th of 6	34	Vigeaux, Sam	(na)	ERA: Theilman, Jake (2.12)	(no team selected)
1904	Browns	79-136 (cmb)	0.368	6th of 6	46.5	Ely, Fred	(na)		(no team selected)
		42-64 (1st)	0.396	6th of 6	21	Dugdale, Dan			
		37-72 (2nd)	0.34	6th of 6	25.5	Butler, Ike			
1905	Giants	94-110 (cmb)	0.461	5th of 6	21	McCredie, Walter	(na)		
		47-54 (1st)	0.465	4th of 6	12.5				
		47-56 (2nd)	0.456	5th of 6	15.5				
1906	Beavers	115-60	0.657	1st of 6	19.5 GA	McCredie, Walter	(na)	Bat. Avg.: Mitchell, Mike (0.351)	(no team selected)
								Homers: Mitchell, Mike (6)	
								W/L Pct.: Essick, Bill (.760, 19-6)	
1907	Beavers	72-114	0.388	4th of 4	41.5	McCredie, Walter	(na)		(no team selected)
1908	Beavers	95-90	0.514	2nd of 4	13.5	McCredie, Walter	(na)	Bat. Avg.: Danzig, Babe (.298)	(no team selected)
								Wins: Groom, Bob (29)	
1909	Beavers	112-87	0.563	2nd of 6	13.5	McCredie, Walter	(na)	Homers: Johnson, Oris (13)	(no team selected)
1910	Beavers	114-87	0.567	1st of 6	1.5 GA	McCredie, Walter	(na)	Strikeouts: Gregg, Vean (376)	(no team selected)
1911	Beavers	113-79	0.589	1st of 6	2 GA	McCredie, Walter	(na)	Bat. Avg.: Ryan, Buddy (.333)	(no team selected)
								Hits: Ryan, Buddy (247)	
								Homers: Ryan, Buddy (23)	
								Wins: Steen, Bill (30)	
								W/L Pct: Steen, Bill (.667, 30-15)	
1912	Beavers	85-100	0.459	4th of 6	26	McCredie, Walter	(na)		(no team selected)
1913	Beavers	109-86	0.571	1st of 6	7 GA	McCredie, Walter	(na)	Hits: Rodgers, Bill (239)	(no team selected)
								Strikeouts: James, Bill (215)	
1914	Beavers	113-84	0.573	1st of 6	3.5 GA	McCredie, Walter	(na)	Homers: Lober, Ty (9)	(no team selected)
								Wins: Higginbotham, Irv (31)	
1915	Beavers	78-116	0.402	6th of 6	33.5	McCredie, Walter	(na)		(no team selected)
1916	Beavers	93-98	0.487	5th of 6	22.5	McCredie, Walter	(na)	Wins: Sothoron, Allen (30)	(no team selected)
1917	Beavers	98-102	0.49	4th of 6	15	McCredie, Walter	(na)	Homers: Williams, Ken (24)	(no team selected)
1918	No team	World War I							
1919	Beavers	78-96	0.448	7th of 8	29.5	McCredie, Walter	141,179		(no team selected)
1920	Beavers	81-103	0.44	8th of 8	21	McCredie, Walter	138,157		(no team selected)
1921	Beavers	51-134	0.276	8th of 8	55.5	McCredie, Walter	85,243		(no team selected)
1922	Beavers	87-112	0.437	7th of 8	40	Kenworthy, Bill	205,929		(no team selected)
						Turner, Tom			
						Demaree, Al			
						Middleton, Jim			
1923	Beavers	107-89	0.546	3rd of 8	14.5	Middleton, Jim	(na)		(no team selected)
1924	Beavers	88-110	0.444	7th of 8	20	Kenworthy, Bill	(na)	Homers: Poole, Jim (38)	(no team selected)
						Brazil, Frank			
1925	Beavers	92-104	0.47	5th of 8	34.5	Lewis, Duffy	(na)		
						Hannah, Truck			
1926	Beavers	100-101	0.498	4th of 8	20.5	Johnson, Ernie	(na)	Homers: Smith, Elmer (46)	3b Prothro, Tommy
1927	Beavers	95-95	0.5	5th of 8	22.5	Johnson, Ernie	(na)	Homers: Smith, Elmer (40)	(no team selected)
1928	Beavers	79-112 (cmb)	0.414	7th of 8	41	Johnson, Ernie	130,479		
		37-55 (1st)	0.402	7th of 8	21	Rogers, Bill			
		42-57 (2nd)	0.424	6th of 8	20				
1929	Beavers	90-112 (cmb)	0.446	6th of 8	33.5	Rogers, Bill	160,038		1b Keesey, Jim
		33-66 (1st)	0.333	8th of 8	30.5				P Mahaffey, Roy
		57-46 (2nd)	0.553	3rd tie of 8	4				
1930	Beavers	81-117 (cmb)	0.409	8th of 8	37	Woodall, Larry	136,029		

YEAR	TEAM	RECORD	PCT.	PLACE	G.B.	MANAGER	ATT.	P.C.L. LEADERS	ALL-STARS
		39-61 (1st)	0.39	8th of 8	18.5				
		42-56 (2nd)	0.429	7th of 8	22				
1931	Beavers	100-87 (cmb)	0.535	3rd of 8	7	Abbott, Spencer	238,340	Runs: Monroe, John (141)	2b Monroe, John
		50-38 (1st)	0.568	2nd of 8	5.5			Hits: Coleman, Ed (275)	OF Coleman, Ed
		50-49 (2nd)	0.505	4th of 8	10			RBIs: Coleman, Ed (183)	UT Riehl, Billy
1932	Beavers	111-78	0.587	1st of 8	5 GA	Abbott, Spencer	207,384	Hits: Finney, Lou (268)	3b Higgins, Frank
									OF Finney, Lou
1933	Beavers	105-77	0.577	2nd of 8	6.5	Abbott, Spencer	154,705		2b Monroe, John
1934	Beavers	66-117 (cmb)	0.361	8th of 8	69	McCredie, Walter	50,731		
		30-52 (1st)	0.366	7th tie of 8	34	Turner, Tom			
		36-65 (2nd)	0.356	7th of 8	34	Burns, George			
1935	Beavers	87-86 (cmb)	0.503	4th of 8	16	Burns, George	228,127		(no team selected)
		31-39 (1st)	0.443	5th of 8	14.5	Ryan, Buddy			
		56-47 (2nd)	0.544	3rd of 8	6.5	Cissell, Bill			
1936	Beavers	96-79	0.549	1st of 8	1.5 GA	Bishop, Max	181,296	Wins: Caster, George (25)	(no team selected)
	(beat Seattle 4-0, beat Oakland 4-1 in playoffs)				Sweeney, Bill			Strikeouts: Caster, George (234)	
1937	Beavers	90-86	0.511	4th of 8	11	Sweeney, Bill	185,824	Runs: Bongiovanni, Tony (136)	(no team selected)
	(beat San Francisco 4-0, lost to San Diego 4-0 in playoffs)							Hits: Bongiovanni, Tony (236)	
								Wins: Liska, Ad (24)	
1938	Beavers	79-96	0.451	6th of 8	24.5	Sweeney, Bill	175,781		(no team selected)
1939	Beavers	75-98	0.434	8th of 8	25.5	Sweeney, Bill	150,756		(no team selected)
1940	Beavers	56-122	0.315	8th of 8	56	Frederick, Johnny	92,338		(no team selected)
1941	Beavers	74-97	0.423	8th of 8	30	Vitt, Ossie	112,984		(no team selected)
1942	Beavers	67-110	0.379	8th of 8	37.5	Brazil, Frank	104,474	Bat. Avg.: Norbert, Ted (.378)	(no team selected)
								Homers: Norbert, Ted (28)	
1943	Beavers	79-76	0.51	4th of 8	31	Shea, Merv	124,790		(no team selected)
	(lost to San Francisco 4-2 in playoffs first round)								
1944	Beavers	87-82	0.515	2nd of 8	12	Owen, Marv	270,835	Wins: Pieretti, Mario (26)	(no team selected)
	(lost to Los Angeles 4-2 in playoffs first round)								
1945	Beavers	112-68	0.622	1st of 8	8.5 GA	Owen, Marv	382,187		(no team selected)
	(lost to San Francisco 4-3 in playoffs first round)								
1946	Beavers	74-109	0.404	6th tie of 8	41	Owen, Marv	314,133	Bat. Avg.: Storey, Harvey (.326)	(no team selected)
1947	Beavers	97-89	0.522	3rd of 8	8.5	Turner, Jim	421,137		
	(lost to Los Angeles 4-1 in playoffs first round)								
1948	Beavers	89-99	0.473	5th of 8	25	Turner, Jim	339,758		(no team selected)
1949	Beavers	85-102	0.454	6th of 8	24	Sweeney, Bill	378,892	Wins: Saltzman, Harold (23)	P Helser, Roy
1950	Beavers	101-99	0.505	4th of 8	17	Sweeney, Bill	348,938		
1951	Beavers	83-85	0.494	4th of 8	16.5	Sweeney, Bill	304,152		(no team selected)
	(lost to Hollywood 2-0 in playoffs first round)								
1952	Beavers	92-88	0.511	4th of 8	17	Hopper, Clay	322,736	ERA: Adams, Red (2.17)	(no team selected)
1953	Beavers	92-88	0.511	4th of 8	14	Hopper, Clay	236,762		P Lint, Royce
1954	Beavers	71-94	0.43	8th of 8	29	Hopper, Clay	135,058		
1955	Beavers	86-86	0.5	5th of 8	9	Hopper, Clay	199,238		
1956	Beavers	86-82	0.512	3rd of 8	21	Holmes, Tommy	305,729	Wins: Valdes, Rene (22)	SS Littrell, Jack
						Sweeney, Bill			OF Marquez, Luis
									P Valdes, Rene
1957	Beavers	60-108	0.357	8th of 8	41	Sweeney, Bill	208,196		
						Carswell, Frank			
						Posedel, Bill			
1958	Beavers	78-76	0.506	4th of 8	11	Heath, Tom	179,100		3b Freese, George
						Jansen, Larry			
1959	Beavers	75-77	0.493	6th of 8	9	Heath, Tom	225,257		3b Freese, George
1960	Beavers	64-90	0.416	8th of 8	28.5	Heath, Tom	116,130	Strikeouts: Mickelsen, Noel (156)	
1961	Beavers	71-83	0.461	5th of 8	26	Benson, Vern	132,834	Homers: Oliver, Gene (36)	1b Oliver, Gene
						Katt, Ray			
1962	Beavers	74-80	0.481	6th of 8	19	Peden, Les	98,525		
1963	Beavers	73-84	0.465	4th of 5 (d)	24.5	Peden, Les	87,438		
						Carnevale, Dan			
1964	Beavers	90-68	0.57	2nd of 6 (d)	1	Lipon, John	207,848		P Tiant, Luis
1965	Beavers	81-67	0.547	1st of 6 (d)	2 GA	Lipon, John	172,291	Strikeouts: Kelley, Tom (190)	1b Davis, Bill
	(lost to Oklahoma City 4-1 in playoff finals)								3b Banks, George
									P Kelley, Tom
1966	Beavers	69-79	0.466	4th of 6 (d)	14	Lipon, John	118,024		P Hettner, Bob
1967	Beavers	79-69	0.534	2nd of 6 (d)	1	Lipon, John	202,507		Mgr Lipon, John
1968	Beavers	72-72	0.5	3rd of 6 (d)	12.5	Davis, John (Red)	110,426		OF Piniella, Lou
									C Fosse, Ray
1969	Beavers	57-89	0.39	4th of 4 (d)	29	Davis, John (Red)	107,423	Homers: Nagelson, Russ (23)	
1970	Beavers	68-78	0.466	2nd of 4 (d)	26	Federoff, Al	119,906		C Felske, John
1971	Beavers	71-71	0.5	2nd of 4 (d)	6.5	Rowe, Ralph	105,565	Wins: Woodson, Dick (16)	
								Strikeouts: Woodson, Dick (163)	
1972	Beavers	61-87	0.412	4th of 4 (d)	18	Hathaway, Ray	91,907		
						Bryant, Clay			
						Carnevale, Dan			
1973–1977		No team							
1978	Beavers	76-62	0.551	2nd of 5 (d)	4.5	Dusan, Gene	96,395	Wins: Wilkins, Eric (15)	(no team selected)
	(tied Tacoma 2-2 in playoffs first round when called by rain)								
1979	Beavers	73-74 (cmb)	0.497	3rd of 5 (d)	6	Lipon, John	159,181	Hits: Cacek, Craig (180)	1b Cacek, Craig
		35-40 (1st)	0.467	5th of 5 (d)	7.5				
		38-34 (2nd)	0.528	2 tie of 5 (d)	2				

Year	Team	Record	Pct	Finish	Manager	Attendance	League Leaders	Awards/Notes
1980	Beavers	69-76 (cmb)	0.476	4th of 5 (d) 13	Mahoney, Jim	129,814	Strikeouts: Mahler, Mickey (140)	OF Salazar, Luis
		34-35 (1st)	0.493	4th of 5 (d) 8				C Pena, Tony
		35-41 (2nd)	0.461	5th of 5 (d) 9				P Mahler, Mickey
1981	Beavers	72-65 (cmb)	0.526	2nd of 6 (d) 5	Ward, Pete	192,214	Strikeouts: Jones, Odell (135)	P Long, Robert
		34-33 (1st)	0.507	2 tie of 6 (d) 1.5				
		38-32 (2nd)	0.543	2nd of 6 (d) 5				
1982	Beavers	65-79 (cmb)	0.451	5th of 5 (d) 19.5	Trebelhorn, Tom	272,781	Wins: Jones, Odell (16)	
		32-39 (1st)	0.451	5th of 5 (d) 10.5			Strikeouts: Jones, Odell (172)	
		33-40 (2nd)	0.452	5th of 5 (d) 10.5				
1983	Beavers	75-67 (cmb)	0.528	1 tie of 5 (d) X	Felske, John	283,688		2b Samuel, Juan
		34-38 (1st)	0.472	3rd of 5 (d) 4				Mgr Felske, John
		41-29 (2nd)	0.586	1st of 5 (d) 4 GA				
	(beat Edmonton 3-1, beat Albuquerque 3-0 in playoffs; 2-2, 2nd of 3 at Triple-A World Series)							
1984	Beavers	62-78 (cmb)	0.443	5th of 5 (d) 12	Elia, Lee	184,143		3b Schu, Rick
		29-40 (1st)	0.42	4th of 5 (d) 5.5				
		33-38 (2nd)	0.465	5th of 5 (d) 8.5				
1985	Beavers	68-74 (cmb)	0.479	3rd of 5 (d) 10.5	Dancy, Bill	188,042		
		36-34 (1st)	0.514	3rd of 5 (d) 1.5				
		32-40 (2nd)	0.444	5th of 5 (d) 9.5				
1986	Beavers	68-73 (cmb)	0.482	4th of 5 (d) 18.5	Dancy, Bill	138,677		2b Legg, Greg
		34-35 (1st)	0.493	3rd of 5 (d) 9.5				
		34-38 (2nd)	0.472	4th of 5 (d) 9				
1987	Beavers	45-96 (cmb)	0.319	5th of 5 (d) 39	Manuel, Charlie	154,989		
		20-49 (1st)	0.29	5th of 5 (d) 18				
		25-47 (2nd)	0.347	5th of 5 (d) 21.5				
1988	Beavers	76-66 (cmb)	0.535	2nd of 5 (d) 9	Mahoney, Jim	207,605	Hits: Rodriguez, Vic (162)	P Best, Karl
		37-33 (1st)	0.529	2nd of 5 (d) 4.5	Shellenback, Jim			
		39-33 (2nd)	0.542	2nd of 5 (d) 4.5				
	(lost to Vancouver 3-0 in playoffs first round)							
1989	Beavers	72-72 (cmb)	0.5	3rd of 5 (d) 5.5	Root, Phil	188,459		1b Torve, Kelvin
		36-36 (1st)	0.5	3rd of 5 (d) 5.5				
		36-36 (2nd)	0.5	3rd of 5 (d) 6.5				
1990	Beavers	56-83 (cmb)	0.403	5th of 5 (d) 21	Root, Phil	150,054	Homers: Brito, Bernardo (25)	
		23-47 (1st)	0.329	5th of 5 (d) 20			ERA: Cook, Mike (3.20)	
		33-36 (2nd)	0.478	2nd of 5 (d) 12.5				
1991	Beavers	70-68 (cmb)	0.507	3rd of 5 (d) 3	Nixon, Russ	181,116	Homers: Brito, Bernardo (27)	P Edens, Tom
		36-32 (1st)	0.529	1st of 5 (d) 2 GA				
		34-36 (2nd)	0.486	3rd of 5 (d) 11.5				
	(lost to Calgary 3-0 in playoffs first round)							
1992	Beavers	83-61 (cmb)	0.576	1st of 5 (d) 1	Ullger, Scott	184,097	Wins: Tsamis, George (13)	OF Brito, Bernardo
		42-30 (1st)	0.583	2nd of 5 (d) 2			Strikeouts: Trombley, Mike (138)	
		41-31 (2nd)	0.569	1st of 5 (d) 3 GA				
	(lost to Vancouver 3-2 in playoffs first round)							
1993	Beavers	87-56 (cmb)	0.608	1st of 5 (d) 13.5	Ullger, Scott	186,010	Wins: Drees, Tom (15)	DH Brito, Bernardo
		42-29 (1st)	0.592	1st of 5 (d) 3 GA			ERA: Mahomes, Pat (3.03)	P Pulido, Carlos
		45-27 (2nd)	0.625	1st of 5 (d) 6 GA				Mgr Ullger, Scott
	(lost to Tucson 4-2 in playoff finals)							
1994–2000		No team						
2001	Beavers	71-73	0.493	3rd of 4 (d) 14	Sweet, Rick	439,686		
2002	Beavers	72-71	0.503	2nd of 4 (d) 10.5	Sweet, Rick	454,197		
2003	Beavers	69-75	0.479	2nd of 4 (d) 5.0	Sweet, Rick	438,931	Stolen bases: Castro, Bernie (49)	2B Castro, Bernie
							Strikeouts: Tankersley, Dennis (148)	

(cmb) – combined / (1st) – first half / (2nd) – second half / (d) – in division